WORLD
FILM
LOCATIONS
BOSTON

Edited by Marcelline Block

First Published in the UK in 2014 by Intellect Books, The Mill, Parnall Road, Fishponds, Bristol, BS16 3JG, UK

First Published in the USA in 2014 by Intellect Books, The University of Chicago Press, 1427 E. 60th Street, Chicago, IL 60637, USA

Copyright ©2014 Intellect Ltd

Cover photo: The Departed (2006) Warner Bros. / The Kobal Collection

Copy Editor: Emma Rhys

Typesetting: Jo Amner

A Catalogue record for this book is available from the British Library

World Film Locations Series
ISSN: 2045-9009
eISSN: 2045-9017

World Film Locations Boston
ISBN: 978-1-78320-198-3
ePDF ISBN: 978-1-78320-242-3
ePub ISBN: 978-1-78320-243-0

Printed and bound by Bell & Bain Limited, Glasgow

WORLD FILM LOCATIONS
BOSTON

EDITOR
Marcelline Block

SERIES EDITOR & DESIGN
Gabriel Solomons

CONTRIBUTORS
Adam Batty
Arnie Bernstein
Henri-Simon Blanc-Hoang
Marcelline Block
Oana Chivoiu
Edward Eaton
Kristiina Hackel
Andrew Howe
Zachary Ingle
Karen Ladany
Lance Lubelski
Kenneth Martin
Dan Akira Nishimura
Monika Raesch
Zachariah Rush
Pamela C. Scorzin
Ila Tyagi
Katherine A. Wagner

LOCATION PHOTOGRAPHY
Edward Eaton
Karen Ladany
Kenneth Martin
Monika Raesch
(unless otherwise credited)

LOCATION MAPS
Joel Keightley

PUBLISHED BY
Intellect
The Mill, Parnall Road,
Fishponds, Bristol, BS16 3JG, UK
T: +44 (0) 117 9589910
F: +44 (0) 117 9589911
E: info@intellectbooks.com

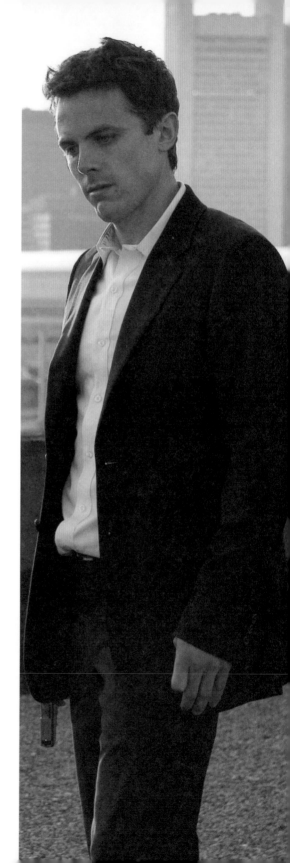

CONTENTS

Maps/Scenes

10 **Scenes 1-8**
1924 - 1972

30 **Scenes 9-16**
1973 - 1982

50 **Scenes 17-24**
1984 - 1997

70 **Scenes 25-32**
1997 - 2003

90 **Scenes 33-39**
2005 - 2010

108 **Scenes 40-46**
2010 - 2012

Essays

6 **Boston:
City of the Imagination**
Monika Raesch

8 **Boston:
Just as Dirty as the Rest**
Edward Eaton

28 **Boston Boys: Matt Damon
and Ben Affleck**
Kristiina Hackel

48 **Beantown Mon Amour:
From Boston with Love**
Ila Tyagi

68 **Post-Human Bostonians:
States of Being in Boston
Sci-Fi Films**
Henri-Simon Blanc-Hoàng

88 **Fenway Park:
The Green Monster on the
Silver Screen**
Zachary Ingle

106 **Veritas and the Crimson
Screen: Harvard in Film**
Marcelline Block

Backpages
124 Resources
125 Contributor Bios
128 Filmography

ACKNOWLEDGEMENTS

I am most deeply indebted to Gabriel Solomons, series editor of
World Film Locations, for his immense guidance and enlightened
direction throughout this volume's production process. It is thanks to
him and his vision for World Film Locations that this book came to
fruition, and I gratefully appreciate everything he has done on behalf
of this project – and all the books in this series – including his inspired
design and artwork. I would also like to extend my sincere gratitude
to Masoud Yazdani and the entire Intellect team, especially James
Campbell, Amy Damutz, Melanie Marshall, Jessica Pennock, Jelena
Stanovnik and May Yao, as well as the University of Chicago Press.
My greatest thanks go to Edward Eaton, Karen Ladany, Ken Martin
and Monika Raesch—all based in Boston—for their outstanding
location photography; to Emma Rhys for copy-editing; to Jo Amner
for assisting with book design and last but not least, I wish to
acknowledge the superb contributors to this volume, whose wonderful
essays and scene reviews are featured herewith.

MARCELLINE BLOCK

INTRODUCTION

World Film Locations Boston

AMONG THE OLDEST CITIES in the United States, Boston, established in 1630, is acclaimed as catalyst of the American Revolution and known as 'Cradle of Liberty'. Silversmith Paul Revere's Midnight Ride in 1775 is immortalized in D. W. Griffith's 1924 film *America*. The City on a Hill has shaped and influenced America's historical, cultural and political landscapes. Also referred to as 'The Athens of America,' Boston boasts a high concentration of colleges/universities, witnessing the vibrancy of its intellectual culture, often central to its cinematic portrayals.

Reflected in Boston, 'site of architectural imagination' (Oana Chivoiu), is its storied/versatile history. Landmarks abound as testaments to its illustrious achievements. In this volume, a selection of 46 film scenes showcases iconic Boston neighbourhoods, from gritty Southie to exclusive Beacon Hill – the domain of 'Boston Brahmins' – and to what Bob Dylan called the 'green pastures of Harvard University', located in the next town, Cambridge, which was settled in 1630 (called Newtowne until 1638) across the Charles River from Boston. From bustling Fenway Park, Copley Square and Newbury Street to the majestic wilderness and lighthouses of the Boston Harbour Islands, *World Film Locations: Boston* explores 'Beantown' and its environs – including Cambridge, Somerville, and Revere, Mass. – spanning nearly 100 years of film-making.

'Even as it has become a twenty-first-century financial centre [Boston] has preserved a provincial culture and accent all its own' (Charles McGrath, *New York Times*), as seen in Boston films including *The Friends of Eddie Coyle* (Peter Yates, 1973) – 'the best movie ever made in Boston [as well as] the most essential movie Hollywood has made' in the Hub (Sherman, pp. iv, 62) – Ben Affleck's violent *The Town* (2010), set in Charlestown, as well as the Southie of *Good Will Hunting* (Gus Van Sant, 1997) and Dorchester of *Gone Baby Gone* (Affleck, 2007).

The City of the Imagination introductory text by Boston-based film scholar Monika Raesch is supplemented by six 'Spotlight' essays addressing how Boston intersects with its on-screen iterations: Fenway Park, the country's oldest functioning Major League Baseball stadium; Ben Affleck and Matt Damon (Affleck, although born in California, grew up near Boston in Cambridge alongside Cambridge native Damon), whose 'love of Boston […] forms the foundation of their creative vision' (Kristiina Hackel); the cinematic significance and presence of Harvard, the oldest and one of the most important institutions of higher learning in the United States – and perhaps the world; and considerations of romance, sci-fi and crime narratives all set in the largest Massachusetts metropolis.

World Film Locations: Boston pays tribute to a city endowed with an indomitable spirit: seven months after the horrific 15 April 2013 Boston Marathon terror attack, in which two adults and a child were slaughtered at the scene while innumerable others were seriously wounded, the Red Sox went on to won the World Series (30 October 2013). This is the first time in nearly a century that the Sox achieved such a magnificent victory in Fenway Park, their home stadium.

The Puritans' *Bay Psalm Book*, published in 1640 in Cambridge, over the Charles River from Boston – in what was then the Massachusetts Bay Colony – is considered 'the first printed book in the land that would eventually become the United States' (Erica Ho, *Time*). One of its eleven remaining copies was auctioned on 26 November 2013 at New York City's Sotheby's, by its owner, Boston's Old South Church (a location discussed in this volume). The *Bay Psalm Book* reaped $14.165 million – thus becoming the world's most expensive printed volume ever sold, illustrating how Boston's cultural relevance and intellectual impact remains grounded in the past while unflinchingly gazing into the future: Boston's recent cinematic production includes the Sandra Bullock blockbuster *The Heat* (Paul Feig, 2013) and David O. Russell's *American Hustle* (2013). Antoine Fuqua's *The Equalizer* and David Dobkin's *The Judge* are slated for release in 2014.

Through its athletic prowess, 'ye great town of Boston in New England in America' (William Price, 1769), incarnates, onscreen and in reality, yet another one of its monikers: 'City of Champions.' ✠

Marcelline Block, Editor

BOSTON

Text by
MONIKA
RAESCH

City of the Imagination

BOSTON'S RICH AND DIVERSE history attracts tourists to its many sites, inviting them to walk the Freedom Trail in order to re-live a part of the American Revolution. Visitors can see a baseball game at the country's oldest ballpark, Fenway Park, where, on 30 October 2013, the Boston Red Sox won the World Series – a major historic victory for the team, marking the first time in nearly 100 years that the Sox won the Series in their home stadium.

Every year people from all over the United States come to Boston to celebrate America's birthday, July 4th, on the Charles River Esplanade, listening to the Boston Pops Orchestra annual outdoor concert held at the Hatch Shell and enjoying the fireworks display over the river. Boston's illustrious history has shown that dreams can become reality. The movie industry has appropriated the city and its past for approximately a century to share some of those dreams, as exemplified by D. W. Griffith's *America* (1924), discussed elsewhere in this volume.

Whether based on true events or fictional narratives, many films make good use of the role Boston locations played in American history. Walking through Boston's downtown area and adjacent neighbourhoods, one encounters the intersection of the history of film production with that of film exhibition in the form of old movie palaces and locations regularly filmed by Hollywood and/or independent movie productions (such as Brad Anderson's 1998 *Next Stop Wonderland*, reviewed in this volume). Along with the eponymous bar made famous by the TV series *Cheers* (Burrows/Charles, NBC, 1982–93), 'Beantown' offers many landmarks known to cinema audiences.

The Boston Common, created in 1634 as America's first public park, is also one of two public parks in the city centre. Boston Common has no flowerbeds, which allows residents to picnic and play ball on its lawn. The film industry has branded this site as a fitting locale for unsavoury characters, such as in the crime film *The Friends of Eddie Coyle* (Peter Yates, 1973), discussed in this volume.

As opposed to Boston Common, Boston's Public Garden – the country's first public botanical garden – features manicured lawns, a lake and vast flowerbeds. Here, on the big screen, protagonists ponder serious matters and enjoy happy times. Imagine Will (Matt Damon) and Sean's (Robin Williams) conversation in the Academy Award winning *Good Will Hunting* (Gus Van Sant, 1997) as you, too, can sit on 'their bench' and watch the swans passing by. Teacher Alice Kinian (Claire Bloom) and her special-needs student Charly Gordon (Oscar winner Cliff Robertson) discuss his upcoming IQ test in *Charly* (Ralph Nelson, 1968). In *Ted* (Seth MacFarlane, 2012), John Bennett (Mark Wahlberg) and Ted – his teddy bear come to life – celebrate Ted's first job surrounded by the Public Garden's swan boats and George Washington statue.

Equally polarizing in their cinematic representation are two Boston bridges: the ultramodern cable-stayed Zakim Bridge (built in 1997) is reserved almost exclusively for heroic protagonists (such as in *Surrogates* [Jonathan Mostow, 2009]; *Knight and Day* [James Mangold, 2010]; *Zookeeper* [Frank Coraci, 2011], and the above-mentioned *Ted*), while the 'bad guys' are typically associated with the Tobin Bridge – New England's largest bridge – or other 'ugly' steel constructions: *Monument Ave.* (Ted Demme, 1998); *The Town* (Ben Affleck, 2010); *Edge of Darkness* (Martin Campbell, 2010).

Crime, thriller, drama and mystery movies are perhaps the most predominant genres filmed in the city today. Three successful examples are based on locally born author Dennis Lehane's novels: *Mystic River* (2001), adapted to screen by Clint Eastwood (2003); *Gone Baby Gone* (1998), adapted to screen by Ben Affleck (2007) and *Shutter Island* (2003) adapted to screen by Martin Scorsese (2010). Homegrown acting talent has impacted the

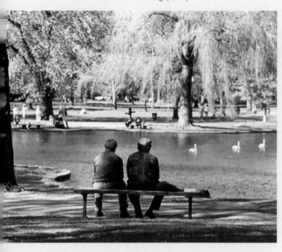

preeminence of these genres as well: Ben Affleck starred in, directed, and co-wrote *The Town* (2010), adapted from the 2004 novel *Prince of Thieves* by Boston-based author Chuck Hogan; Matt Damon and Mark Wahlberg had leading roles in Martin Scorsese's *The Departed* (2006), and Denis Leary starred in *Monument Ave.*

The multifaceted history of Boston – whether political (*A Civil Action* [Steven Zaillian, 1998]); academic (*The Great Debaters* [Denzel Washington, 2007]); social (*The Witches of Eastwick* [George Miller, 1987]), or sports-related (*Celtic Pride* [Tom DeCerchio, 1996]; *Fever Pitch* [Bobby and Peter Farrelly, 2005]) – has provided a set of films that are 'quintessential New England'. They could not be set anywhere else, as they are inextricably linked to Boston, largest city of this region. Often, New England is represented as a place steeped in tradition, regardless of whether the movie was actually shot there and its narrative unfolds in the area (*With Honors* [Alek Keshishian, 1994]; *Grown Ups* [Dennis Dugan, 2010]) or only the plot is situated in New England's past and custom (*All that Heaven Allows* [Douglas Sirk, 1955]). Many films centre around the area's medical history (*Mystery Street* [John Sturges, 1950]; *Coma* [Michael Crichton, 1978]; *Whose Life is it Anyway?* [John Badham, 1981]) as well as the presence of Harvard, Ivy League

Whether based on true events or fictional narratives, many films make good use of the role Boston locations played in American history.

university par excellence – the oldest, and probably most elite, university in the United States – such as *Love Story* (Arthur Hiller, 1970), *The Paper Chase* (James Bridges, 1973), *With Honors, Legally Blonde* (Robert Luketic, 2001), *The Social Network* (David Fincher, 2010). At the same time, Boston and New England double as many world film locations that do not resemble the region in the least: Paris (*Pink Panther 2* [Harald Zwart, 2009]) and Alaska (*The Proposal* [Anne Fletcher, 2009]).

Besides historic movie locations, many exhibition spaces in Boston also explore earlier times. Standing on Boston Common, looking across the street onto a multiplex, one can imagine that in 1915, the Tremont Street Theater stood at this very location, successfully run until the Depression. D. W. Griffith's landmark 1915 film *Birth of a Nation*, featuring Lillian Gish, was screened here. From the late 1940s onwards, first-run features would play in its replacement, The Astor. The theatres may have changed, but this Tremont Street site seems forever dedicated to movie exhibition.

Even more inspiring, several original theatres line Boston's streets to this day: the Majestic – now known as the Cutler Majestic Theatre – is located a block down the same street. It opened in 1903 and to this day, continues hosting performances. One block away, on Washington Street, the Modern Theatre became the city's first sound theatre in 1913. Declared a Boston Landmark in 1995, it still functions for movie screenings. A few doors down, the Paramount Theatre, also restored, is in operation. It originally opened in 1932 and remains the best example of art deco style in Boston. To this day, the small front facades of many businesses are reminders of another era's taxation laws: property owners were taxed partially on the amount of storefront that bordered Washington Street. Consequently, entrances are small, leaving to the imagination the big movie houses that lie behind these front doors. (For an in-depth history, see *Boston's Downtown Movie Palaces* in the Images of America series.)

While the success of the tax credit that was implemented in 2005 to (re-) attract Hollywood to Boston is debatable, Beantown has certainly been consecrated by the film industry, and productions are in town throughout the year. Many street corners, alleyways and buildings have been depicted onscreen to tell stories of comedy, crime, drama, romance and everything in between. For residents of the Hub, the question always is: which street or house façade will next be represented on the big screen? ✠

BOSTON

Just as Dirty as the Rest

Text by
EDWARD
EATON

BOSTON IS KNOWN for its history and its impact on the development of the United States. It was home to the instigators of the American Revolution, and the ongoing 'great experiment' was guided by local luminaries: John Adams, Benjamin Franklin and John Hancock. During an American infancy stained by slavery, Boston became a hub for the Abolitionist Movement (Massachusetts was the second state to ban slavery and the first to free its slaves): the first anti-slavery tract published in America, Samuel Sewall's *The Selling of Joseph*, was published in Boston in 1700; *The Liberator*, the country's leading abolitionist newspaper before the Civil War, was created, edited and printed in Boston for three decades by William Lloyd Garrison. The state produced and/ or educated eight US presidents, plus a number of heads-of-state from other countries. The Greater Boston area is home to some of the finest, most prestigious universities in the world--including Harvard and MIT--and has hosted more than 200 Nobel Laureates. A significant number of poets, novelists, artists, musicians, actors and athletes hail

from Boston. The metropolitan area is home to the Boston Symphony, Massachusetts General Hospital, the Red Sox and the original Dunkin' Donuts.

Bostonians pride themselves on the rich history and vibrant culture of their city. Yet beneath Boston's Puritan heritage lays a dangerous and seedy underbelly. Ponzi schemes originated in Boston. The Great Brink's Robbery and the Boston Strangler serial killer are infamous local crime events, both of which have been commemorated onscreen (in films discussed in this volume). Convicted murderer Willie Horton, imprisoned in Boston, made national headlines, when in 1986, while released as part of a prison weekend furlough program, he fled the region and committed additional violent acts, for which he is incarcerated for life in Maryland. Notorious leader of Boston's Irish mob and the Winter Hill Gang, Whitey Bulger – arrested in California in 2011 after nearly twenty years of evading capture – grew up on the tough streets of South Boston. In Scorsese's *The Departed* (2006), Frank Costello, the Boston mob boss played by Jack Nicholson, is based upon Bulger. Another take on Bulger's narrative is the forthcoming cinematic adaptation of Dick Lehr and Gerard O'Neill's book *Black Mass: Whitey Bulger, the FBI, and a Devil's Deal* (2000), currently in production – with South Boston filming locations – to be released in 2014.

Boston's criminal element has attracted film-makers fairly early on in the history of modern film. The first movie primarily filmed in Boston was John Sturges's 1950 *Mystery Street/Murder at Harvard*, with settings at Harvard Medical School, among other localities. The Academy Award nominated *Mystery Street* is considered the first 'police procedural'. Several critically acclaimed crime films made in the last decade are situated in the Boston area. *The Departed* was awarded four Oscars, including Best Picture. Clint Eastwood's

Mystic River (2003), an adaptation of Dennis Lehane's eponymous 2001 novel, stands out in a high-profile group that includes *Southie* (John Shea, 1999), which explores strife between Irish gangs and served as an early film for Donnie Wahlberg, Rose McGowan and Will Arnett; Ben Affleck's 2007 *Gone Baby Gone*, based on another eponymous Lehane novel (1998), about police corruption and the kidnapping of a Dorchester girl, and Affleck's violent heist thriller *The Town* (2010), adapted from Chuck Hogan's book *Prince of Thieves* (2004). *The Town*'s epigraph informs the audience that the film's setting of Charlestown – Boston's oldest neighbourhood – 'has produced more bank robbers and armoured car thieves than anywhere in the world' as bank robbery is a family business. Recent significant crime films based in the Hub include Scorsese's *Shutter Island* (2010), adapted from Lehane's 2003 novel, and Paul Feig's female-driven buddy cop comedy/thriller *The Heat* (2013), a box office success starring Melissa McCarthy and Sandra Bullock. These films explore a dark side of Boston not featured on its popular Duck Tours.

Crime is not just concentrated on the city's lower depths. The film world has also explored crime in some of the area's more exalted sites. *Harvard Man* is James Toback's 2001 light-hearted thriller about point shaving in basketball and organized crime. More serious, and

successful, is *21* (Robert Luketic, 2008), based on the MIT Blackjack Team, whose supposedly 'true story' is told by Ben Mezrich in his book *Bringing Down the House: The Inside Story of Six MIT Students Who Took Vegas for Millions*, from which the film was adapted. Even the rich and successful are not immune to the lure and thrill of crime. Norman Jewison's 1968 caper, *The Thomas Crown Affair*, narrates how a wealthy Beacon Hill resident turns to crime to alleviate his boredom/ennui.

In the spirit of Beantown's literary past, several significant crime films that take place in metropolitan Boston are based on popular books. Dorchester native Dennis Lehane penned the novels *Mystic River*, *Gone Baby Gone* and *Shutter Island*, all of which were adapted into major motion pictures, while Chuck Hogan, born in Massachusetts and educated at Boston College, is the author of *Prince of Thieves*, upon which *The Town* is based (see above). The Irish American mob film, *The Friends of Eddie Coyle* (Peter Yates, 1973), starring Robert Mitchum as the titular hood and snitch, is based on George V. Higgins's eponymous 1970 novel. Disney's 1957 film adaptation of Esther Forbes's beloved 1943 young adult novel, *Johnny Tremain*, examines the titular protagonist's coming of age in colonial Boston on the eve of the American Revolution, evoking the prerevolutionary atmosphere as well as historical events such as the Boston Tea Party and the Midnight Ride of Paul Revere. Brad Silberling's 2004 *Lemony Snicket's A Series of Unfortunate Events* is set in Boston (yet was not filmed on-location, but primarily on California soundstages), though it is unclear where the book series is set.

Boston criminals are not just millionaires (*Thomas Crown*), geniuses (*21*) or patriots (*Johnny Tremain*). They are also folk heroes (*The Brink's Job* [William Friedkin, 1978]), vigilantes (*The Boondock Saints* [Troy Duffy, 1999]), serial killers (*The Boston Strangler* [Richard Fleischer, 1968]), and crusaders (Sidney Lumet's 1982 *The Verdict*).

Bostonians pride themselves on living in a city that they consider more educated, more historical and more sophisticated than most other cities in the United States. It is not as crass as Las Vegas, as star-studded as Los Angeles, as business-driven as New York, as corrupt as Washington DC. Yet as suggested by its cinematic depictions, Boston is just as dirty as the rest, as summed up in the title of 'The Dirty Old Boston Project', an online photographic archive/history of the city, to be published as a book in 2014.✦

Bostonians pride themselves on the rich history and vibrant culture of their city. Yet beneath Boston's Puritan heritage lays a dangerous and seedy underbelly.

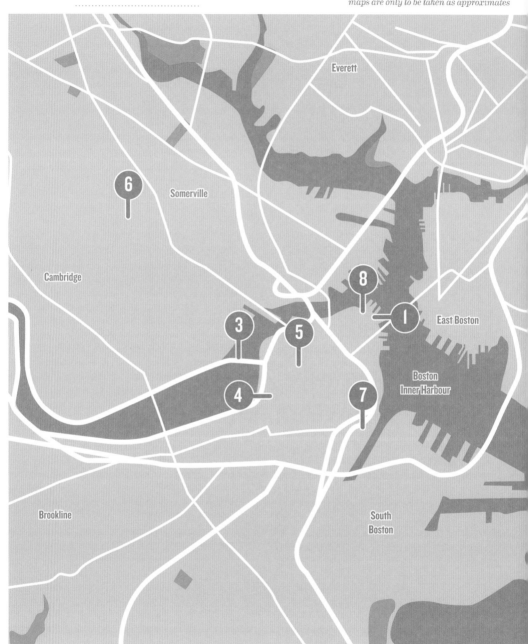

BOSTON LOCATIONS
SCENES 1-8

Revere

Winthrop

Boston
Harbour

1.
AMERICA (1924)
Old North Church, 193 Salem Street
page 12

2.
PORTRAIT OF JENNIE (1948)
The Graves Light, Boston Harbour Islands
National Recreation Area
page 14

3.
THE BOSTON STRANGLER (1968)
Longfellow Bridge
(aka Salt 'n' Pepper Bridge)
page 16

4.
CHARLY (1968)
'Nemur-Straus Clinic', 5 Commonwealth
Avenue at Arlington Street
page 18

5.
THE THOMAS CROWN AFFAIR (1968)
The 2nd Harrison Gray Otis House,
85 Mount Vernon Street
page 20

6.
LOVE STORY (1970)
119 Oxford Street, Cambridge
page 22

7.
THE OUT OF TOWNERS (1970)
South Station, 700 Atlantic Avenue
(between East Street and Essex Street)
page 24

8.
FUZZ (1972)
Copp's Hill Burying Ground, 21 Hull Street
page 26

AMERICA (1924)

LOCATION *Old North Church, 193 Salem Street*

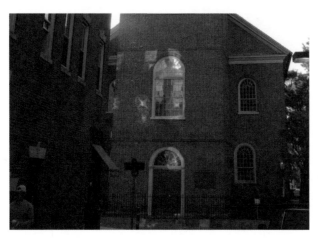

'THE SIGNAL FOR THE BRITISH MARCH SHALL BE – One, if by land; Two, if by sea.' So says one of the intertitles in this silent Revolutionary War epic, quoting the famous line from Longfellow's 1860 poem 'Paul Revere's Ride'. The Old North Church played a pivotal role in alerting colonists to the movements of the British Army on the night of 18 April 1775. Paul Revere had instructed the church's sexton to hang one lantern in the steeple if the king's troops were arriving over Boston Neck and the Great Bridge, and two if they were taking boats across the Charles River. Griffith stages the iconic scene by cutting back and forth between the Charlestown shore and the church, located at 193 Salem Street in the North End. Built in 1723, it is the oldest standing church building in the city. The steeple was destroyed in the Storm of October 1804, and replaced by one designed by Bostonian architect Charles Bulfinch, itself felled by Hurricane Carol in August 1954. The steeple on view today fuses design elements from both the original and Bulfinch iterations. Revere (Harry O'Neill) rows over the water and runs toward the other riders silhouetted on the riverbank. They look in the direction of the church for a long beat. Suddenly, a shot of the steeple with its distinctive miniature spires appears. Two lights beam clearly from the belfry, and Revere embarks on his midnight ride. ➥*Ila Tyagi*

Directed by D. W. Griffith
Scene description: Two lanterns in the steeple signal that
the British Army is arriving across the Charles River
Timecode for scene: 0:43:22 – 0:44:22

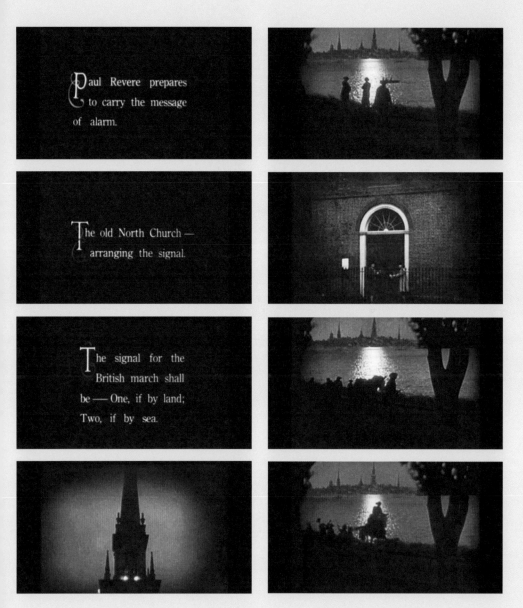

Paul Revere prepares
to carry the message
of alarm.

The old North Church —
arranging the signal.

The signal for the
British march shall
be — One, if by land;
Two, if by sea.

Images © 1924 D. W. Griffith Productions

PORTRAIT OF JENNIE (1948)

The Graves Light, Boston Harbour Islands National Recreation Area

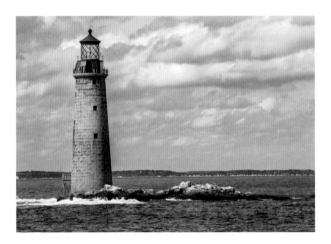

EBEN ADAMS is a struggling artist. He is in debt and in arrears. But one day, inspiration irrupts into his life when he meets a young girl named Jennie. After painting a portrait of Jennie, he is able to paint and sell his work – but Jennie and Eben's love is inextricably linked to Eben's romanticist belief in himself as an artist. When Jennie disappears, so does Eben's talent. Searching for Jennie, Eben travels to Land's End Light House, a purely fictional place; in reality, however, the scene was filmed at the Graves Light, a lighthouse in Boston Harbour. This ambiguity comprising the mythically real – what-is-is-what-is-not – is the central trope of the narrative. The name Eben Adams looks all-too-suspiciously like the Biblical names Adam and Eden. Jennie, whose surname is Appleton, is an innocent, Eve-like girl sent to assuage Adams's weltschmerz, but is, herself, the forbidden fruit. Adams tastes from the lips of Appleton and falls not into sin but into love. Adams – having eaten of the forbidden fruit – is condemned, losing Jennie in a supernatural storm that engulfs the lighthouse. One might push the Edenic analogy further by suggesting the image of the Serpent appears as the spiral staircase that sinews up the core of the lighthouse (the Sacred Tree). On the other hand, one might consider the entire narrative to be a starving artist's hallucination. Either way there appears to be no better monument to this fable than a Pharos. **➻Zachariah Rush**

Photo © Karen Ladany

Directed by William Dieterle
Scene description: The lighthouse sequence, Adam loses Jenny in the storm
Timecode for scene: 1:10:00 – 1:21:00

THE BOSTON STRANGLER (1968)

Longfellow Bridge (aka Salt 'n' Pepper Bridge)

IN HIS 1845 POEM 'The Bridge', Henry Wadsworth Longfellow stood contemplatively over the Charles River on a moonlit midnight in June. In contrast, in Richard Fleischer's *The Boston Strangler*, a self-styled Othello – who famously strangled his wife Desdemona in Shakespeare's tragedy – is chasing his prey with the Longfellow Bridge as a backdrop. The police are quick to respond and arrest him. It turns out that this 'Othello' is insane, suffering from messianic delusions, but his proclivity for strangling alarms the authorities who are in the throes of Boston Strangler panic. This self-styled Othello is taken into custody and questioned, but the Strangler Bureau quickly realizes that the real Strangler remains at large. The Longfellow Bridge spans the Charles River, connecting Beacon Hill with Kendall Square in Cambridge. It is known by many locals as the 'Salt and Pepper' bridge owing to the shape of its four towers which look peculiarly like salt shakers. These towers are clearly visible in the background of this scene. The current Bridge was named in 1927 to honour poet Henry Wadsworth Longfellow who had walked upon its early predecessor – then called the West Boston Bridge – where he was inspired to write the above-mentioned poem in 1854. Wadsworth expressing sentiments such as 'Each bearing his burden of sorrow' and 'the young heart hot and restless', seem almost prescient in light of the counter-culture movement of the 1960s and Boston's strangling terror to come. ➙*Zachariah Rush*

Photo © Ken Martin / Amstockphoto.com

Directed by Richard Fleischer
Scene description: Self-styled 'Othello' attacks his Desdemona on the bridge
Timecode for scene: 0:35:00 – 0:36:00

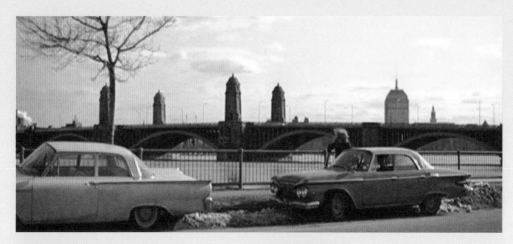

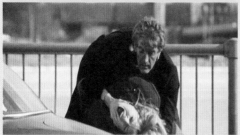

CHARLY (1968)

'Nemur-Straus Clinic', 5 Commonwealth Avenue at Arlington Street

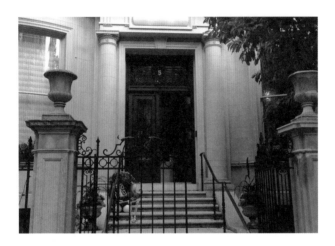

MOVIE DIRECTORS CAN CHOOSE from many locations when they need to shoot a scene that takes place in a hospital or a research facility in Boston. Michael Crichton's *Coma* (1978), for instance, is filmed at Boston City Hospital and Massachusetts General Hospital, while the research centre of Ken Russell's *Altered States* (1980) is located in the basement of Harvard Medical School. Nevertheless, for his *Charly*, Ralph Nelson picked a traditional Victorian building to host the 'Nemur-Straus Clinic', where the main character (Charly) undergoes a series of tests that are supposed to measure his intelligence. In fact, the apparent simplicity of this house, with its narrow stairs and its lack of ostentatious ornaments, makes up for the oversized ego of its founders, who have named the research facility after themselves. Supposedly, Dr Nemur and Dr Strauss's breakthrough discovery will allow educationally-challenged people like Charly to become geniuses after a painless surgery. The image of their 'discrete' (but extremely ambitious) clinic contrasts with the shoot of the 'Beekman College Center for Retarded Adults', the school in which the main character has been attending night classes in the hope of slowly learning how to read and write. The architectural style of this place, with its Greco-Roman columns and wide stairs at its entrance, seems disproportionate compared to the low (but realistic) expectations that its faculty have of their educationally-challenged students. At first, the message seems clear: isolated, privately-founded research institutions, named after people who are still alive, can do a better job for mentally-handicap people than traditional universities. The end of *Charly*, however, suggests otherwise. ➥ **Henri-Simon Blanc-Hoàng**

Photo © Edward Eaton

Directed by Ralph Nelson
Scene description: Charly leaves the clinic in anger
Timecode for scene: 0:30:51 – 0:34:22

THE THOMAS CROWN AFFAIR (1968)

LOCATION

The 2nd Harrison Gray Otis House, 85 Mount Vernon Street

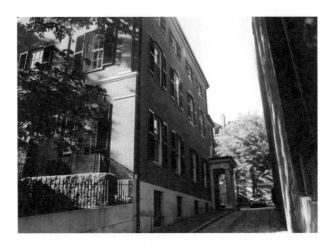

BY THE TIME Thomas Crown drives his Rolls Royce home, the audience knows that he is dangerous: not only is he a successful businessman, but moreover, a criminal mastermind. Later, the audience learns that he is a sportsman and a gambler who likes living on the edge. His arrival home, though, is particularly significant, as his home is the 2nd Harrison Gray Otis House – designed by Charles Bulfinch – the only freestanding single-family home remaining in Boston's elite Beacon Hill neighbourhood. Not much is said in the film about Crown's family background: educated at Dartmouth, he is divorced (his ex-wife retained custody of their children); he is worth $4 million (nothing to sneeze at, but not *that* much money – even in the 1960s). Somehow, in the divorce, he was able to keep this 14,000-square foot, nine-bedroom house. While it is not explained, perhaps this was because it was a family home. Beacon Hill is known as home for Boston's aristocracy. The 1999 remake of the film puts Crown in New York, a fast city filled with cut-throat businessmen and nouveau riche, among others. A Boston Crown is part of a quieter, more subdued, more sophisticated gentility. Crown's Mount Vernon Street home indicates that he comes from old money. When Crown leaves his car and walks across the cobblestone driveway, the audience realizes that he is not a common criminal. This is not a New York plutocrat. This is a Boston Brahmin. Americans long for an aristocracy. That is why we excuse Crown's criminal activities. **➻ Edward Eaton**

Photo © Edward Eaton

Directed by Norman Jewison
Scene description: Thomas Crown (Steve McQueen) arrives home
Timecode for scene: 0:25:35 – 0:26:04

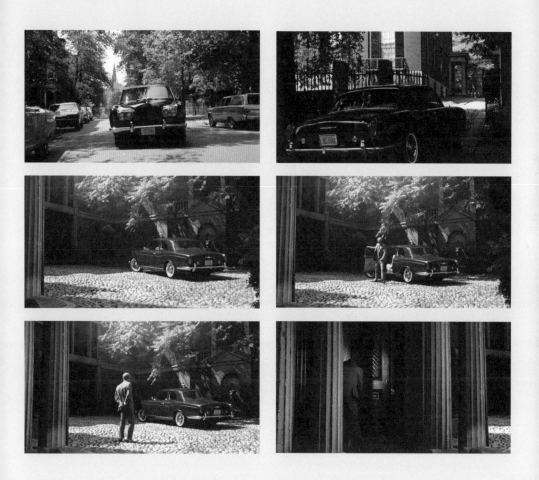

LOVE STORY (1970)

LOCATION *119 Oxford Street, Cambridge*

BELOVED BY AUDIENCES and reluctantly admired by serious critics, *Love Story* was the highest grossing film of 1970 and garnered seven Academy Award and seven Golden Globe nominations. Directed by Arthur Hiller, the romantic tearjerker tells the story of wealthy Harvard undergrad Oliver Barrett IV (Ryan O'Neil), who falls in love with Jennifer 'Jenny' Cavalleri (Ali MacGraw), a working-class Radcliffe student. They marry, despite Oliver's father's objections, and live happily ever after until tragedy strikes. Supported by a poignant instrumental theme written by Francis Lai and a nostalgic flashback structure, the film hits all the high notes of a tragic romance. Notwithstanding the heavy tone, Oliver and Jennifer are refreshing and instantly likeable because of the way they interact: what Oliver calls their 'verbal volleyball'. After their do-it-yourself wedding, Oliver and Jennifer leave campus housing and move into their first apartment together at 119 Oxford Street. They are poor, because of Oliver's estrangement from his father, and Jennifer doesn't believe that they can find housing they can afford 'on this side of Mongolia'. Oliver welcomes her to the 'Mongolian section of Cambridge'. She takes a look at the decrepit apartment building and tells him it is even worse than she imagined. But, at her request, he cheerfully carries her over the threshold all the same. Later, after a fight, he finds her on the steps of the apartment to apologize, and she delivers the film's most memorable line: 'Love means never having to say you're sorry.'

⇢Kristiina Hackel

Photo © Ken Martin / Amstockphoto.com

Directed by Arthur Hiller
Scene description: Recent newlyweds Jennifer and Oliver move into
their new apartment and Oliver carries her over the threshold
Timecode for scene: 0:46:30 – 0:47:16

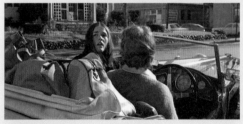

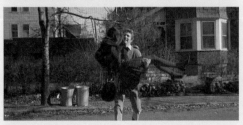

THE OUT OF TOWNERS (1970)

South Station, 700 Atlantic Avenue (between East Street and Essex Street)

IF ONE IS TRAVELLING to New York when Murphy's Law takes effect there is perhaps no more likely place to be diverted than Boston. This is exactly what happens to George and Gwen Kellerman. In a desperate effort to get to New York in time to attend a job interview, George (Jack Lemon) and Gwen (Sandy Dennis) must rush from Logan airport to Boston's historic South Station to catch the last night train to New York. Murphy's Law, like gravity, is inviolable so everything that can go wrong does go wrong. South Station becomes the locus of frustrations and follies. George finds a cab and demands to get to South Station in ten minutes. 'South Station's a fifteen minute drive. I can't make a fifteen-minute drive in ten minutes,' the driver retorts. When they arrive, George only has a $20 bill to pay for a ride that costs a little over a dollar, and because of haggling over the fare, George and Gwen arrive in time to watch helplessly as the last train leaves the platform. In his 1898 inaugural speech Boston mayor Josiah Quincy III referred to South Station as a 'wide and spacious gateway of unrestricted freedom'. But for out-of-towners George and Gwen Kellerman, South Station proves anything but unrestricted as they encounter one impediment after another. But this should not be surprising: it was, after all, the sage cynicism of Bostonian poet Robert Lowell who informed us that the light at the end of the tunnel is really an oncoming train.

→Zachariah Rush

Photo © Monika Raesch

Directed by Arthur Hiller
Scene description: George and Gwen rush to South Station
to make the last night train bound for New York City
Timecode for scene: 0:21:00 – 0:25:00

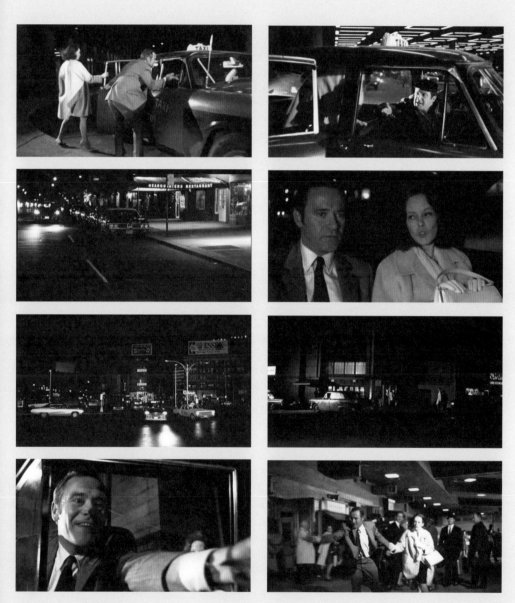

FUZZ (1972)

LOCATION *Copp's Hill Burying Ground, 21 Hull Street*

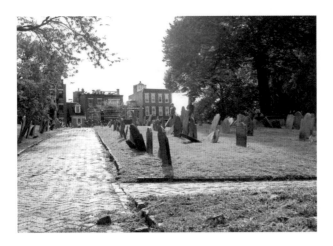

IN FUZZ, an idiosyncratic group of cops try to find and stop a criminal who demands money from the city of Boston or he will murder public officials. This ragtag bunch of police is played by Burt Reynolds, Raquel Welch, Tom Skerritt, James McEachin and Jack Weston. The bad guy, played by Yul Brynner, finds small children to take his notes with demands to the police station. Brynner's character demands that large sums of money, hidden inside lunch pails, are left in various spots throughout Boston. The first place where the villain tells the police to leave him money is in Copp's Hill Burying Ground in Boston's North End. Kling (Skerritt) and Brown (McEachin) hide in the cemetery and wait for the criminal to grab the pail from a bench. This stakeout is cross-cut with scenes at the police station where the unit has to deal with colourful locals and meddling painters. Kling calls the station and is told to 'follow and contain' whoever grabs the pail. Eventually, a man takes the pail and dashes off, followed by the two detectives. The chase continues on the T, and then through a local market. On the train, the guy being followed opens the pail, only to find it full of wood, not money. Kling and Brown lose him, while many other sites in Boston throughout the film depict this game of cat-and-mouse. **⇢ Lance Lubelski**

Photo © Karen Ladany

Directed by Richard A. Colla
Scene description: Kling and Brown conduct a stakeout at Copp's Hill Burying Ground
Timecode for scene: 0:16:32 – 0:20:33

BOSTON BOYS

Text by
KRISTIINA
HACKEL

Matt Damon and Ben Affleck

WHEN MATT DAMON and Ben Affleck won the Academy Award for Best Screenplay for *Good Will Hunting* (Gus Van Sant, 1997), they each thanked Boston in their acceptance speeches. Such thanks are appropriate, since Damon's and Affleck's careers owe so much to the city of Boston. Childhood friends, Damon and Affleck grew up in Cambridge blocks apart from each other, where they played Little League, attended Cambridge Rindge & Latin School and took drama classes together. Few childhood friendships have been as enduring and productive as that of Damon and Affleck's, who supported each others' acting careers, wrote together and now produce together through their production company, Pearl Street Films. Damon and Affleck's love of Boston, its history and streets, forms the foundation of their creative vision.

Good Will Hunting – which grossed $226 million worldwide and garnered nine Academy Award nominations, most famously winning Damon and Affleck the Academy Award for Best Screenplay – draws heavily on their Boston experiences. The film tells the story of Will Hunting (Damon), a troubled math genius working as a janitor whose life is changed by an MIT math professor (Stellan Skarsgård) and a therapist (Robin Williams). The film is informed by Damon and Affleck's own Boston roots, and is full of real locations like the Red Line T that Will rides back from his job as an MIT janitor to South Boston, the South Boston L Street Tavern Will and his best friend Chuckie (Ben Affleck) frequent, the bench in the Public Gardens where Will and Sean go to talk, the Au Bon Pain on Harvard Square where Will and his girlfriend, Harvard undergraduate Skylar (Minnie Driver) study. In one of the funnier scenes of the film, Will slams the piece of paper on which Skylar wrote her number against the window of the Harvard Square Bow Street Dunkin' Donuts to show up the annoying Harvard graduate student who earlier had tried to embarrass him and his friends, saying 'How do you like dem apples?' an expression Damon and Affleck had used frequently growing up. These real Boston locations capture the difference in the Cambridge and Southie experiences, giving the film a reality and weight.

After *Good Will Hunting*, Damon and Affleck developed their acting careers internationally, but both returned to their hometown for Boston-set films. In Scorsese's *The Departed* (2006), Damon plays Collin Sullivan, a mob-funded mole

placed in the Special Investigations Unit of the Massachusetts State Police. As with co-star Mark Wahlberg, who grew up in Dorchester, Damon's Boston roots helped him secure the role. Although some of the film was shot in Brooklyn, the film is filled with Boston locations: the headquarters of the 'Special Investigation Unit' is Erich Lindeman Mental Health Center, on Staniford Street; Sullivan can see the golden dome of the Massachusetts State House on Beacon Street from his apartment; and the exterior of mob boss Costello's headquarters, the Charles Street Brasserie, is a makeover of the Charles Street Cleaners on Beacon Hill.

Affleck returned to Boston for his feature film-directing debut. *Gone Baby Gone* (2007), about two private investigators looking for a kidnapped girl, is based on the eponymous 1998 novel by Dennis Lehane, also a Boston native who grew in up in Dorchester. *Gone Baby Gone* was

the first Lehane novel Affleck read, and he approached the author with his high school friend, Aaron Stockard, with an interest in writing the adaptation. Originally intending only to write and act in the film, Affleck's desire to direct grew out of his investment with and connection to the material, an understanding intensified by the fact he had just become a father.

Good Will Hunting – which grossed $226 million worldwide and garnered nine Academy Award nominations, most famously winning Damon and Affleck the Academy Award for Best Screenplay – draws heavily on their Boston experiences.

For a Boston story, it was important for Affleck to film in Boston. As he said in a 2007 *New York Times* interview with Charles McGrath,

'I wanted something raw and authentic and even a little scuffed up. People go to the movies to see something they can't get otherwise, and I thought this was a chance to take you somewhere that you couldn't otherwise get to – the Boston you never see in the movies'

He pushed this authenticity further by shooting B-roll throughout the city and hiring Boston locals for extra and, unusually, speaking roles. For the mother, Helene McCready, Affleck had trouble finding actors who could do a proper Boston accent until he saw Amy Ryan. It is no accident that he cast his own brother, Casey Affleck, a talented Boston native, to play the lead detective, Patrick Kenzie.

Affleck retuned to Boston and the crime drama for his second feature, *The Town* (2010), the story of four friends trying to get away with a series of robberies without being caught by the FBI. Affleck co-wrote, directed and starred in the film, which was nominated for an Academy, Golden Globe, SAG, PGA and WGA Award, primarily for Jeremy Renner's supporting actor role of James Coughlin. A more commercial film than *Gone Baby Gone*, *The Town* pushed Affleck's range with high-budget action scenes in iconic locations such as Fenway Park, as well as more intimate scenes in other true Boston locations such as the Thornton Flower Shop in Dorchester, Old Sully's bar in Charleston, and, perhaps an Affleck trademark, a crucial scene set in a Dunkin' Donuts on Tremont Street.

Fresh off his Best Motion Picture (Academy Awards, Golden Globes) and Best Director (Golden Globes, DGA) wins for his third directing effort, *Argo* (2012), Affleck will be returning to Boston for his next directorial effort, *Live By Night*, slated for release in 2015, based on another Dennis Lehane novel (2012) – a prohibition tale about the son of a police captain who gets caught up in organized crime. Affleck will also direct the pilot of the period crime drama series, 'The Middle Man', recently picked up by Fox, which is also a mob-focused story set in 1960s Boston. Damon and Affleck will reunite on the screen in another Affleck-directed upcoming crime drama, a biopic about Boston mobster Whitey Bulger, whose history influenced *The Departed*. These future Boston projects will find Damon and Affleck comfortably back at home. ✥

LOCATIONS MAP

BOSTON

maps are only to be taken as approximates

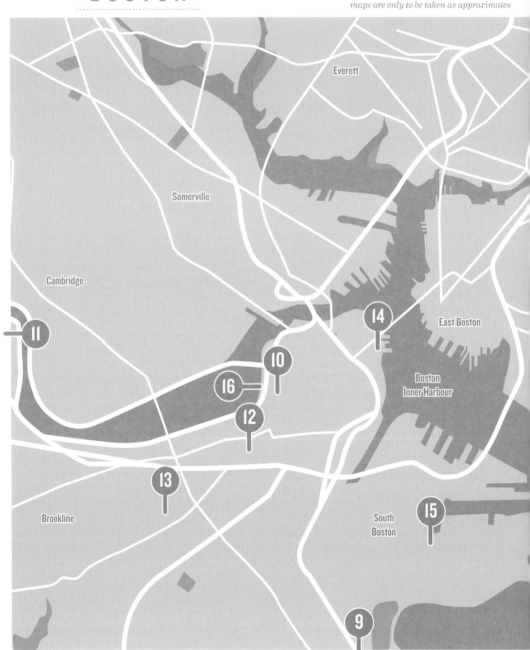

BOSTON LOCATIONS
SCENES 9-16

Revere

Winthrop

Boston
Harbour

9.
THE FRIENDS OF EDDIE COYLE (1973)
Boston Bowl, 820 William T. Morrissey Blvd,
Dorchester
page 32

10.
THE LAST DETAIL (1973)
Boston Common, Charles Street
page 34

11.
THE PAPER CHASE (1973)
Harvard Stadium, 65 North Harvard Street,
Allston
page 36

12.
THE BRINK'S JOB (1978)
The old Boston Police Headquarters in the
Back Bay neighbourhood (which became the
Jurys Boston Hotel and is now the Loews
Boston Hotel), 154 Berkeley Street
page 38

13.
ALTERED STATES (1980)
Harvard Medical School, 25 Shattuck Street
page 40

14.
WHOSE LIFE IS IT ANYWAY? (1981)
Christopher Columbus Waterfront Park,
Atlantic Avenue and Richmond Street
page 42

15.
ONCE AROUND (1981)
Basilica of Our Lady of Perpetual Help
(Mission Church), 1545 Tremont Street
page 44

16.
THE VERDICT (1982)
William F. Spencer Funeral Home,
575 East Broadway
page 46

THE FRIENDS OF EDDIE COYLE (1973)

Boston Bowl, 820 William T. Morrissey Blvd, Dorchester

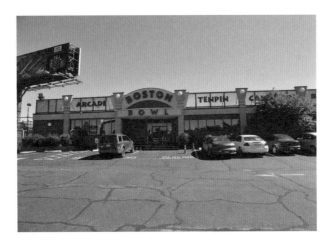

EDDIE COYLE (ROBERT MITCHUM) is a Boston career criminal now over fifty who can't do more time. Unfortunately, he got in a beef in New Hampshire where the rules are tougher and it looks like he's going down. He reaches out to Dave Foley (Richard Jordan) an undercover Fed in a black leather coat, on the snitch detail. Eddie is ready to do a favour for 'Uncle', the DA Earlier, he'd purchased guns from Jackie Brown (Steven Keats), who deals out of the trunk of his souped-up Dodge. When they meet again at a bowling alley, Eddie, who claims to be working for a higher-up, pressures Jackie to come up with more guns the following night. Jackie resists, saying he deals in 'quality' merchandise that 'takes time'. 'I'm not gonna' screw it up just because your people got hot drawers.' Eddie responds: 'One of the first things I learned was never ask a man why he's in a hurry ... I'm gettin' old, you hear?' Mitchum looks the part, but his Boston Irish accent seems forced, at times. More convincing are Jordan, Peter Boyle and Alex Rocco. Keats, as the gun dealer, is a standout in the ensemble cast. His Jackie is a compelling portrait of a young man of that era, dressed up like a rock star with a Keith Richards hairdo while navigating the underworld. The cars, the clothes, and Dave Grusin's faux-funky sound cues, place the film squarely in the 1970s.

⊷ *Dan Akira Nishimura*

Photo © Ken Martin / Amstockphoto.com

Directed by Peter Yates

Scene description: A hotshot gun dealer is set up

Timecode for scene: 0:43:40 – 0:47:02

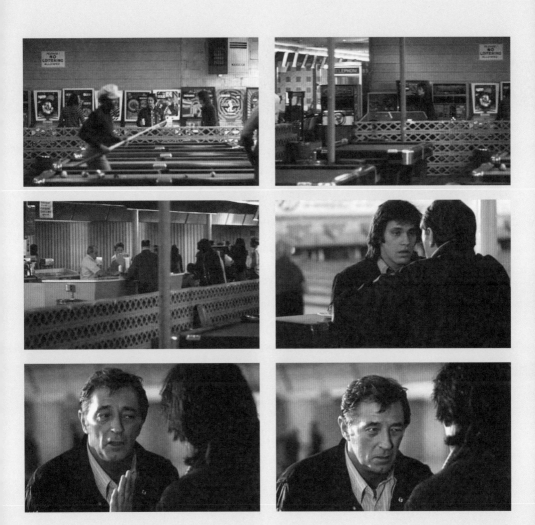

THE LAST DETAIL (1973)

LOCATION *Boston Common, Charles Street*

TWO GRIZZLED NAVY LIFERS, Billy 'Badass' Buddusky (Jack Nicholson) and Richard 'Mule' Mulhall (Otis Young) are escorting Larry Meadows (Randy Quaid) from their Virginia base to the Naval brig near Portsmouth, New Hampshire where he is to serve an eight-year sentence. His crime? Meadows tried to lift forty bucks from a charity collection-box that was the pet project of his commanding officer's wife. Buddusky and Mulhall take pity on their dimwitted charge. Given that they have a few days to transport Meadows to his final destination, the worldly-wise duo decide to show the naïve sailor a good time before he is clapped behind bars. Their journey takes them from Washington to New York, and finally to Boston where Meadows has his first sexual experience with a young hooker (Carol Kane) in the city's red-light district Combat Zone. Fun to be sure, but what Meadows *really* wants is a picnic. Though it's the dead of winter, the trio heads to Boston Common to roast hot dogs. Meadows tries to escape his companions, in a desperate move, but is recaptured and brought to his final destination. Boston Common is to Beantown what Central Park is to New York City. Once the headquarters of British troops during the Revolutionary War, today it is filled with scenic walking trails, softball fields, outdoor art and memorials, and a setting for free concerts. In spring, summer and fall this is a beautiful space within the city. In the winter it can be a bleak and empty territory, qualities Ashby brings out in *The Last Detail* through stark documentary realism. During shooting, Nicholson lost a shoe as he chased Quaid down through the snow-encrusted terrain of the park, but the camera kept rolling as both men remained in character throughout a long unbroken shot. The Common becomes the metaphor for Meadows's immediate future: cold, brutal, and a place without refuge. **➻ Arnie Bernstein**

Photo © Edward Eaton

Directed by Hal Ashby
Scene description: Dead-of-winter picnic
Timecode for scene: 1:27:22 – 1:35:08

 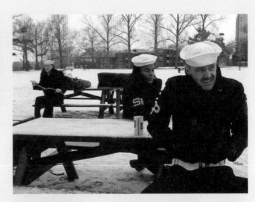

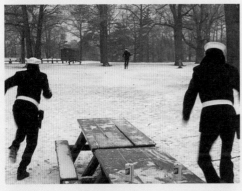

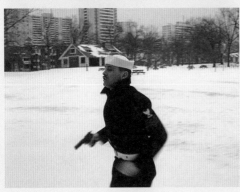

THE PAPER CHASE (1973)

LOCATION

Harvard Stadium, 65 North Harvard Street, Allston

JAMES HART (TIMOTHY BOTTOMS) and Susan Fields (Lindsay Wagner) converse in the emptiness of Harvard Stadium. He is a first-year student at Harvard Law School; she is the daughter of Professor Charles W. Kingsfield Jr. (John Houseman in his Oscar winning role), an enigmatic and powerful teacher whom James both admires and fears. Although he is proving to be successful academically, James feels as empty as the stadium he occupies in this scene. To him, gaining recognition from the demanding Professor Kingsfield has become important, and he pushes Susan not only about her father but also about taking their relationship to a more serious level. Susan, on the other hand, does not want to think about the future. Avoiding James's attempts to get her to commit more fully, she talks about the past, about a time when she sat with her father and the President of the United States watching the Harvard football team compete. Although both are young, intelligent and seemingly headed for success, neither Susan nor James are at all happy. She is in the process of going through a messy divorce, and law school is not living up to his expectations. Neither of them feels fulfilled, and their happiness as they reconcile at the end of this scene and he chases her down the stadium steps seems temporary. In order to move forward with their relationship, both James and Susan will need to figure out what is most meaningful for themselves, and how the other might be a part of that future. **⇌ *Andrew Howe***

Photo © Monika Raesch

Directed by James Bridges
Scene description: James and Susan argue about their relationship
Timecode for scene: 1:02:48 – 1:05:18

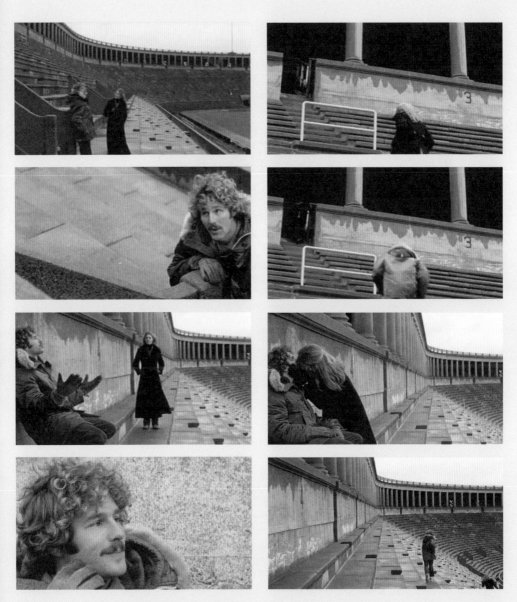

Images © 1973 Thompson-Paul Productions/Twentieth Century Fox Film Corporation

THE BRINK'S JOB (1978)

The old Boston Police Headquarters in the Back Bay neighbourhood (now the Loews Boston Hotel), 154 Berkeley Street

WILLIAM FRIEDKIN'S *The Brink's Job* is one in a long line of heist films – a genre jump-started by 1973's *The Sting* (George Roy Hill). *The Brink's Job* is based on the historical 1950 robbery of more than 1 million dollars from the Brink's Building in Boston's North End. Part of the charm of this dark comedy is the occasional glimpse of old 1940s Beantown as imagined and realized by Production Designer Dean Tavoularis (also the production designer for Francis Ford Coppola's *Godfather I, II* and *III*). Friedkin's (and Tavoularis's) view of the neighbourhoods of Boston is affectionate – particularly the predominantly Italian North End. Neighbours are friendly, races mix freely, the characters are happy archetypes, streets are safe, and everybody knows your name. Everyone knows Tony Pino's (Peter Falk) name. At least the police do. After another company is robbed (off-screen), the police haul in Boston's coterie of smalltime hoods and wannabe goodfellas. As the people of interest parade up the stairs and into the Boston Police Headquarters, Pino is greeted with a friendly 'how do you do?' by the cops. Pino, in response, is friendly right back. This scene sets up how Pino, already the leader of his small group of keystone crooks, is a well-known figure in the Boston crime scene, which is described by local fence Joe McGinnis (Peter Boyle) as resembling a small town. Pino is just the type of two-bit crook who the authorities will question after the Brink's Job is pulled – and dismiss as being too inconsequential. The casualness of this procession to the police headquarters also anticipates the circus-like atmosphere at the courthouse that will greet the gang members at the end of the film when they are herded past their adoring fellow Bostonians to their sentencing (filmed at the old Custom House, Downtown). **↝ Edward Eaton**

Photo © Edward Eaton

Directed by William Friedkin
Scene description: Tony Pino is brought in for a routine round-up of the usual suspects
Timecode for scene: 0:42:40 – 0:42:52

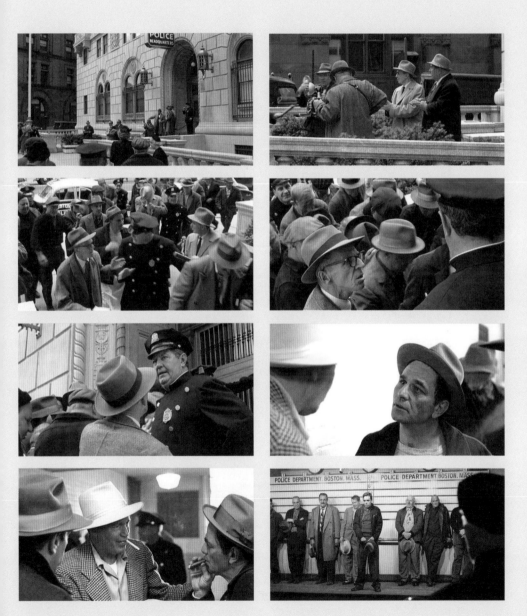

Images © 1978 Universal Pictures

ALTERED STATES (1980)

LOCATION *Harvard Medical School, 25 Shattuck Street*

IN BOTH THE ARTS (see Leonardo Da Vinci's *Vitruvian Man*, ca. 1490) and Science (see the geometry problem of attempting 'to square the circle'), the circle is considered a naturally occurring shape while the human-created square represents our hopeless attempt at precisely controlling Nature. *Altered States* relies frequently on the circle vs the square contrast. The occurrence of either shape in the film depends on whether the protagonist conducts his experiments in a natural or man-made environment. In the scene that precedes the presentation of his research proposal at Harvard Medical School, Eddie Jessup (William Hurt) goes through a psychedelic trip (caused by his consumption of peyote). This episode, however, takes place in a natural environment, where the round/circle shape appears both at the entrance of the cave and around the pot in which Mexican Indians prepare Eddie's hallucinogen. In this case, Nature is still in charge. Once in Boston, however, the main character hopes to combine the use of his peyote-based drug with a session in an isolation tank. This is when the symbol of the square becomes omnipresent. Eddie first tries to reproduce his earlier psychedelic trip inside a square isolation booth. He then decides to inspect a discarded square isolation tank that has been left in the basement of Harvard Medical School. Coincidently, the first isolation tank that the camera shows at the beginning of the film presents a 'natural' round shape (a cylinder). This is not the case with the new isolation tank that Eddie wants to use in combination with the consumption of his peyote-based drug. Finally, even the facade of Harvard Medical School (with its almost perfect square front-entrance) presents a sharp contrast with the rounded entrance of the cave where Mexican Indians prepare their natural drug. **➻Henri-Simon Blanc-Hoàng**

Directed by Ken Russell
Scene description: A psychedelic trip recreated at Harvard Medical School
Timecode for scene: 0:40:05 – 0:42:31

Images © 1980 Warner Bros.

WHOSE LIFE IS IT ANYWAY? (1981)

LOCATION *Christopher Columbus Waterfront Park, Atlantic Avenue and Richmond Street*

WHOSE LIFE IS IT ANYWAY?, based on Brian Clark's eponymous 1978 play, presents a debate over an incurable patient's rights to decide the end of his life. It questions what constitutes the boundaries between a patient and a person along with their legal rights. The film opens with the young and successful sculptor Ken Harrison (Richard Dreyfuss) finishing the montage of his project in Boston's Christopher Columbus Waterfront Park. The scene is emotionally and aesthetically vibrant as Ken shares a feeling of accomplishment with his team of students. In addition, we get a glimpse of his playful relationship with Pat (Janet Eilber) who is a ballet dancer and with whom he shares many artistic interests. The camera moves from the construction site where the giant metal sculpture is installed, to show with a panoramic view of the park its new artistic addition. The image of Ken's work defining the architectural make-up of the city introduces him as an urban visionary. Images of Boston as site of architectural imagination are briefly present only in the opening scenes. What follows after Ken's car accident is the world of the hospitalized, bed-ridden patient. The only continuity between the world of the person and that of the patient is Ken's mind, which becomes very similar with a battlefield. He fights with his new identity as a patient, with doctors, the hospital and the legal system in order to decide his life options.

➠ Oana Chivoiu

Directed by John Badham
Scene description: The montage of a sculpture in Christopher Columbus Waterfront Park in Boston
Timecode for scene: 0:0:20 – 0:3:15

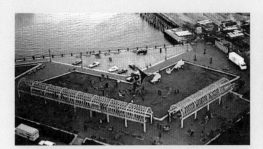

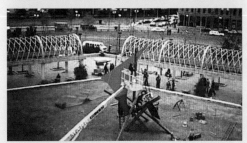

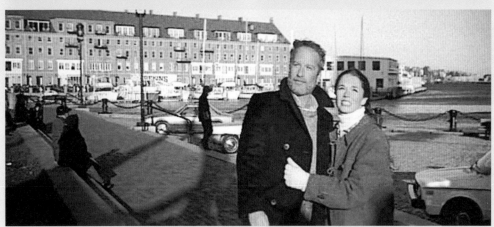

Images © 1981 Metro-Goldwyn-Mayer (MGM)/SLM Production Group

ONCE AROUND (1991)

LOCATION *Basilica of Our Lady of Perpetual Help (Mission Church), 1545 Tremont Street*

ONCE AROUND follows comic and dramatic moments in the relationship of two characters who meet at a moment when both are contemplating an emotional dead end in their lives. Their relationship is intense and self-absorbed and, consequently, many times misunderstood by the family. After a fight with the family over details about their daughter's baptism, Renata (Holly Hunter) and Sam (Richard Dreyfuss) decide not to invite anyone to the baptism. The baptism scene features a beautiful Boston location, the Basilica of Our Lady of Perpetual Help, and represents a turning point in the plot. While it is a moment of celebration of a new life, it is also a moment that anticipates the end of another. The fact that the church is empty allows us to contemplate its grandiose proportions that are meant not only to accommodate a big crowd but also to inspire religious feelings. The emotional intensity of the moment, doubled by the joy of having the family surprise them with their presence at the baptism, are too much for Sam's weak heart. The camera captures the moment from different angles and appears to align itself with an omnipresent eye that has visionary knowledge about the narrative's direction. Initially constructed as a close-up, the moment when Sam faints is, toward the end of the scene, filmed from a very high vantage point in the cathedral, which symbolically conflates with a gaze that has a religious and visionary dimension. ◆**Oana Chivoiu**

Scene description: Baptism in Our Lady of Perpetual Help Basilica
Timecode for scene: 1:32:09 – 1:36:10

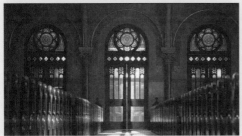

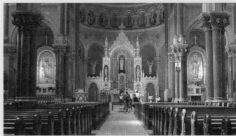

THE VERDICT (1982)

LOCATION *William F. Spencer Funeral Home, 575 East Broadway*

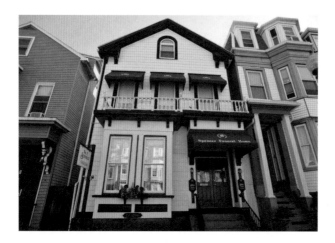

IN SIDNEY LUMET'S sombre drama, Paul Newman plays Frank Galvin, an alcoholic ambulance chaser trying to make a comeback as a respected attorney. The opening scenes masterfully set him up as a man gone to seed. He greases the palm of a funeral director for the privilege of handing out his business card to bereaved relatives. He squirts perfume into his mouth to disguise the smell of drink. At the William F. Spencer Funeral Home, the deceased man's son recognizes him as an imposter and Galvin is thrown out. As he skulks away licking his wounds, the camera lifts into a high-angle shot looking down a sloping South Boston street. Dirty snow litters the pavement: Galvin is, both literally and figuratively, out in the cold. A longtime partner later tosses him what looks like an open-and-shut medical malpractice case. Rather than settling, Galvin chooses to go to trial, recognizing that championing the plaintiff is his last shot at personal and professional redemption. His eyes gleam with zeal as he pours all his energy into defeating the corrupt counsel for the defence, Ed Concannon (James Mason). We no longer recognize the washed-up man we saw loitering in funeral homes surrounded by death. Galvin has found a new lease on life. **⇢Ila Tyagi**

Photo © Ken Martin / Amstockphoto.com

Directed by Sidney Lumet
Scene description: Galvin tries giving his business card to relatives of the deceased
Timecode for scene: 0:3:36 – 0:5:12

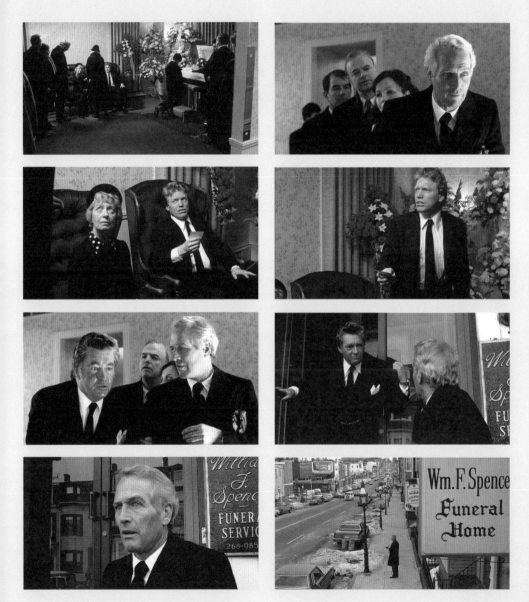

BEANTOWN MON AMOUR

Text by
ILA TYAGI

From Boston with Love

A CURSORY REVIEW of the locations where most popular romantic comedies take place yields a few steadfast results: New York, Los Angeles and London crop up repeatedly in such genre classics as *Annie Hall* (Woody Allen, 1977), *Pretty Woman* (Garry Marshall, 1990) and *Love Actually* (Richard Curtis, 2003), respectively. Seattle and Paris deserve honourable mention as well, with, respectively, Nora Ephron's *Sleepless in Seattle* (1993) gifting audiences Tom Hanks and Meg Ryan's terrific on-screen chemistry for the second time (they were first seen together in 1990 in John Patrick Shanley's *Joe Versus the Volcano*) and *Amélie* (Jean-Pierre Jeunet, 2001) launching countless Francophiles into swooning paroxysms of bliss. But what of Boston? Beantown does not appear in rom-coms as frequently, perhaps because Hollywood favours the tried-and-true, and the aforementioned classics constitute a powerful tradition of setting successful rom-coms in the same iconic metropolises. Nevertheless, a significant group of several significant rom-coms feature Boston as an integral component of their plots. In *Fever Pitch* (Bobby and Peter Farrelly, 2005), Lindsay (Drew Barrymore) falls for Ben

(Jimmy Fallon), a rabid Red Sox fan. Their love blossoms throughout the winter, but when baseball season rolls around Ben's fanaticism threatens the relationship (*Fever Pitch* was based on the 1997 British film of the same name, itself adapted from Nick Hornby's 1992 bestseller about a loyal Arsenal fan whose love life is linked to the team's roller coaster fortunes in the football league).

Similarly, *Everybody Wants to be Italian* (Jason Todd Ipson, 2007) unfolds in Boston's Little Italy, on the North End. It is a case of mistaken ethnicity as two star-crossed lovers pretend to be Italian in order to win each other's hearts. Other romantic comedies based in and around Boston include *Legally Blonde* (Robert Luketic, 2001) – set at Harvard, but mostly filmed in California – *Alex & Emma* (Rob Reiner, 2003), *My Best Friend's Girl* (Howard Deutch, 2008), *Ghosts of Girlfriends Past* (Mark Waters, 2009), *The Invention of Lying* (Ricky Gervais and Matthew Robinson, 2009), *What's Your Number?* (Mark Mylod, 2011). Harvard also provides the backdrop for the ultimate Bostonian love story: *Love Story* (Arthur Hiller, 1970). Ryan O'Neal and Ali MacGraw's tearjerker was what *Variety* called 'the first of the modern-day blockbusters' (Margalit Fox, *New York Times*), grossing nearly $200 million and rescuing its studio, Paramount Pictures, from the brink of financial ruin. *Love Story* received seven Academy Award nominations, including one for Erich Segal's screenplay, which spawned several lines now inscribed in public memory, including the iconic 'Love means never having to say you're sorry'.

Women lined up outside theatres to see *Love Story* in the afternoons, then brought their husbands back the same night to watch it again. They engaged patternmakers to copy the stylish camel coat that MacGraw wore in the film. Queen Elizabeth chose the film for honours at England's Twenty-Fifth Royal Film Festival. Leukemia was for a time known as '*Love Story* disease'. A 1971 *Saturday Evening Post* article captures the way this

Above © 1968 United Artists
Opposite © 1970 Love Story Company, Paramount Pictures

college romance instantly felt timeless: a young store clerk interviewed by the journalist describes it reverently as '*Romeo and Juliet* at Harvard'.

Harvard is the setting for a very different love story in *Alma Mater* (Hans Canosa, 2002). Taking place just prior to John F. Kennedy's assassination in 1963, the film charts a love triangle that is two-thirds gay. Arthur Knight (Will Lyman) is an associate professor whose wife suspects him of wooing one of his students, Molly Thayer (Kate Super). In truth, Arthur is seeing his teaching assistant, Charlie Greene (Andrew van den Houten). Charlie's crush on Molly further complicates an already fraught tale of private emotion swept up in social upheaval.

Boston's other major university, MIT, is the stage upon which *Good Will Hunting* (Gus Van Sant, 1997) sets its scene. Though the film is remembered primarily for Sean Maguire's (Robin Williams) touching mentorship of Will (Matt Damon), Will's volcanic passion for beautiful and bright Harvard medical student Skylar (Minnie Driver) drives the film toward its all-American final shot: a car zipping across open road as Will heads for California to 'go see about a girl'. The 1990s were good times for celluloid Boston courtships. Besides *Good Will Hunting*, the decade saw the release of *Once Around* (Lasse Hallstrom, 1991), *The Opposite Sex and How to Live with Them* (Matthew Meshekoff, 1992), 1992's *Housesitter* (Frank Oz), a Goldie Hawn/Steve

Martin rom-com (filmed in nearby Concord), *Never Met Picasso* (Stephen Kijak,1996), *Starving Artists* (Allan Piper, 1997), *This Just In …* (David J. Lagana, 1997), *The Proposition* (Lesli Linka Glatter, 1998) and *Next Stop Wonderland* (Brad Anderson, 1998), among others.

Moving a little further back in time, 1979's *Starting Over* (Alan J. Pakula) stars Burt Reynolds as a recently divorced magazine writer, Phil Potter, trying to choose between his alluring ex-wife (Candice Bergen) and quirky preschool teacher Marilyn (Jill Clayburgh). Quincy Market plays a small but vital role in Phil and Marilyn's budding romance – going grocery shopping there is one of their first activities together as a couple, and Phil later returns to the market to have a duplicate apartment-key cut when Marilyn moves in. Steve McQueen plays the eponymous bored Boston millionaire in *The Thomas Crown Affair* (Norman Jewison, 1968). He masterminds a bank heist and ends up becoming involved with the chic insurance agent assigned to investigate the case, Vicki Anderson (Faye Dunaway). *Feelin' Good* (James A. Pike, 1966) has the distinction of being a musical love story. A veteran returning home from Germany, Ted (Travis E. Pike), finds that his girlfriend Karen (Patricia Ewing) has formed a rock 'n' roll band called the Brattle Street East. Their ecstatic reunion is briefly marred when Karen mistakenly suspects Ted of having eyes for her roommate, but with the aid of much bubblegum song-and-dance, harmony is eventually restored.

Of course, no review of love stories based in Boston would be complete without *Now, Voyager* (Irving Rapper, 1942). *Now, Voyager* was adapted from the third volume in Olive Higgins Prouty's tetralogy about a wealthy Boston family, the Vales, written between 1936 and 1947. Bette Davis is Charlotte Vale, a mousy heiress bullied by her overbearing mother (Gladys Cooper). Charlotte retreats into a sanitarium and is there transformed into a sophisticated swan. While on a South American cruise, she falls tremulously and tremendously in love with married architect Jerry Durrance (Paul Henreid). Charlotte and Jerry's *amour fou* is a bumpy ride for both of them, and its ending back in Charlotte's hometown is bittersweet. Davis famously urges Henreid not to wish for the moon when they have the stars. For the rest of us, there is the potent image of a perfect partner lighting two cigarettes and handing over one of them to us. ✤

Women lined up outside theatres to see *Love Story* in the afternoons, then brought their husbands back the same night to watch it again.

LOCATIONS MAP

BOSTON

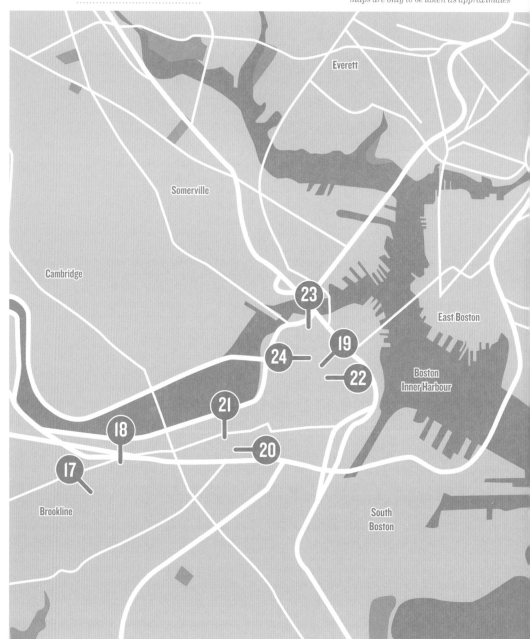

BOSTON LOCATIONS
SCENES 17-24

17.
THE BOSTONIANS (1984)
Gibson House Museum, 137 Beacon Street
page 52

18.
FIELD OF DREAMS (1989)
Fenway Park, 4 Yawkey Way
page 54

19.
GLORY (1989)
Memorial to the 54th Massachusetts Colored
Regiment, 14 Beacon Street
page 56

20.
THE FIRM (1993)
Copley Plaza Hotel, 138 St James Avenue
page 58

21.
BLOWN AWAY (1994)
Copley Square, 560 Boylston Street
page 60

22.
WITH HONORS (1994)
Boston Athenaeum, 10½ Beacon Street
page 62

23.
CELTIC PRIDE (1996)
Boston Garden, 150 Causeway Street,
(now TD Garden, 100 Legends Way)
page 64

24.
AMISTAD (1997)
Massachusetts State House, 24 Beacon Street
page 66

THE BOSTONIANS (1984)

LOCATION

Gibson House Museum, 137 Beacon Street

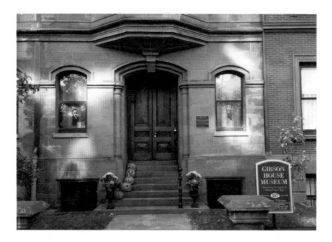

THE GIBSON HOUSE MUSEUM is a National Historic Landmark, a Victorian row home whose perfectly preserved interiors capture urban American domestic life from 1860–1916. The house stands in for Olive Chancellor's (Vanessa Redgrave) residence in the Merchant Ivory adaptation of Henry James's novel, set in 1875–76. Olive is an unmarried woman of means closely involved with the suffragist movement. She meets Verena Tarrant (Madeleine Potter) at a political meeting, and is fascinated by her. However, Olive's cousin, Mississippi lawyer and Civil War veteran Basil Ransom (Christopher Reeve), is smitten by Verena as well. Olive and Basil lock horns in a fierce battle for Verena's attachment. Olive persuades Verena to move into her home and begins training her for a career as an activist. A sumptuous red-walled room serves as their study. The two gather there to read feminist tracts and their correspondence with other colleagues in the movement. Descending the main staircase in Gibson House, wily journalist Mr Pardon (Wallace Shawn) urges Verena's father (Wesley Addy) to think of Verena as a potential moneymaker. Olive is seen writing out a check in the red study to Dr Tarrant in exchange for the privilege of being left completely alone with his daughter for a year. She creeps into the upstairs bedroom of the house to discover her vulnerable protégée asleep. The vertical stripes on the bedroom wallpaper evoke a jail cell: despite her hesitations about her own commitment to Olive's cause, Verena is now trapped. ✤**Ila Tyagi**

Photo © Edward Eaton

Directed by James Ivory
Scene description: Olive Chancellor's well-appointed Victorian home
Timecode for scene: 0:17:00 – 0:31:54

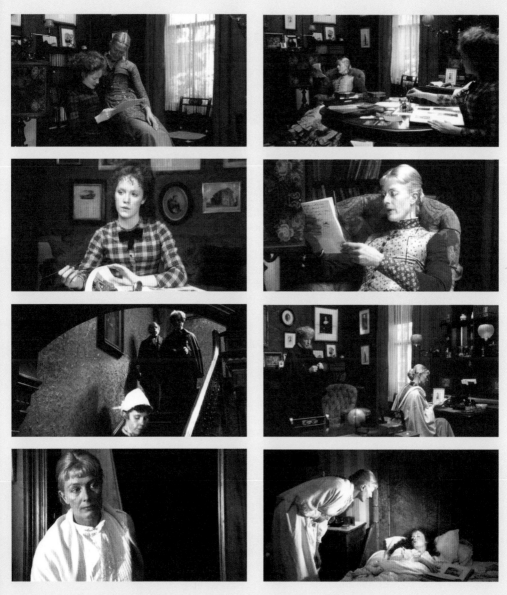

FIELD OF DREAMS (1989)

LOCATION *Fenway Park, 4 Yawkey Way*

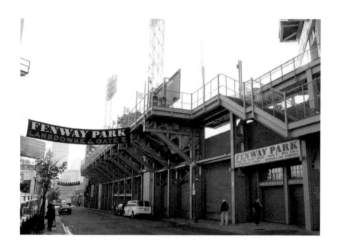

MIDWAY THROUGH THE CLASSIC baseball film *Field of Dreams*, protagonist Ray (Kevin Costner) pleads author and former activist Terence (James Earl Jones) to join him for a ballgame at Fenway Park near Kenmore Square in Boston. The film frequently incorporates elements of fantasy while Ray has metaphysical encounters with a dead baseball player called Shoeless Joe Jackson – one of eight players banned for match fixing during the infamous Black Sox scandal in 1919. The heritage of Fenway Park, home of the Boston Red Sox since 1912 and the oldest Major League Baseball stadium still in use, lends itself to the plot, which often references the history of baseball. Ray's journey from a small farming community in Iowa to one of the great bastions of baseball in New England is depicted like a pilgrimage. In a crowded stadium, only Ray and Terence can hear a voice whisper 'Go the distance' and see the name of a 1922 baseball player displayed on the scoreboard screen. In the context of the film, Fenway Park is not as much a sporting arena as a temple where the forgotten souls of the game come back to life. Intriguingly, most parts of this scene take place away from the actual game itself: in the zigzagging gangways below the seats or at the hot dog vendor. The film thus emphasizes the notion that the legacy of baseball cannot only be found in the game itself, but also, that it extends to the people and the memories behind the game. In addition, Fenway Park is portrayed as a place where two absolutely contrasting people, such as Ray and Terence, are able to transcend their differences and connect with each other via their shared love for the game.
↦ Marco Bohr

Photo © Monika Raesch

Directed by Phil Alden Robinson
Scene description: Ray and Terence watch a baseball game together at Fenway Park
Timecode for scene: 0:0:52– 0:0:55

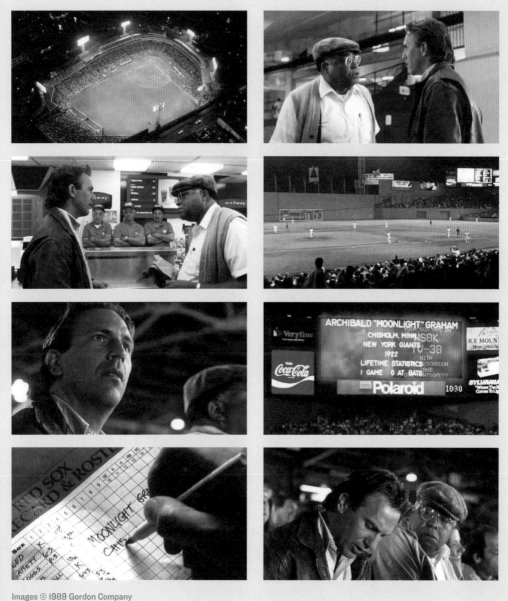

Images © 1989 Gordon Company

GLORY (1989)

LOCATION

Memorial to the 54th Massachusetts Colored Regiment, 14 Beacon Street

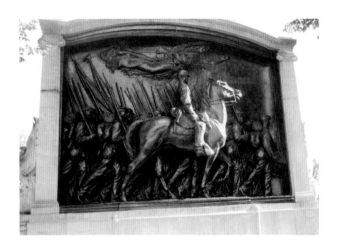

PRODUCER FREDDIE FIELDS originally thought about making *Glory* after stumbling upon the Robert Gould Shaw Memorial as he was walking through the Boston Common. Since this relief was unveiled in 1897 (i.e.: more than a generation after the end of the Civil War), this artwork was not included in the plot of the film. Nevertheless, in addition to appearing as an extra-diegetical image in the end credits, this tri-dimensional fresco became the source of inspiration for a very important moment in the movie: the 28 May 1863 parade of the 54th Massachusetts Regiment through Beacon Street before their deployment to Georgia. Although filmed in Savannah, this scene reveals a missing side-view that the original sculpture does not show. In the motion picture, the regiment passes in front of the governor of Massachusetts and Frederick Douglass. Commanding Officer Robert Gould Shaw (Matthew Broderick) salutes these two historical figures with his sabre, while riding his horse. The camera then shows Shaw on his horse in the background, and Douglass in the foreground. This part of *Glory* and the actual Memorial complement each other, giving us views of the scene from opposite sides of the same tri-dimensional image. Moreover, when sculptor Augustus Saint-Gaudens began working on the Memorial in the 1890s, he only had access to photographs of Colonel Shaw. For the sculptures of the enlisted men, the Bostonian artist had to hire models because he could not find close-up pictures of soldiers from the 54th Massachusetts Colored Regiment. If Colonel Shaw is an identified historical figure who appears on the Memorial, his men are unknown soldiers. However, *Glory* gives names (although fictitious) back to these men. In the end credits, actors' names appear superimposed over the still image of the Memorial. Ironically, two of the soldiers depicted in the monument strongly resemble Denzel Washington and Morgan Freeman, whose characters appear in the same place (in formation) as their lookalikes in the relief. ➥***Henri-Simon Blanc-Hoàng***

Photo © Edward Eaton

Directed by Edward Zwick
Scene description: *End credits roll over the Robert Gould Shaw Memorial*
Timecode for scene: *1:55:37 – 1:58:01*

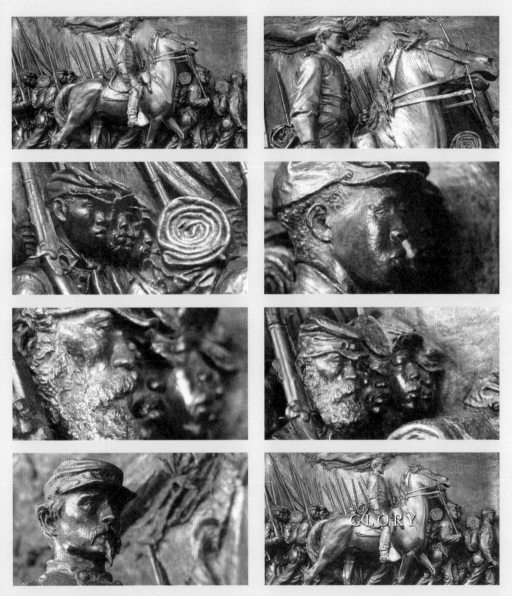

THE FIRM (1993)

LOCATION

Copley Plaza Hotel, 138 St James Avenue

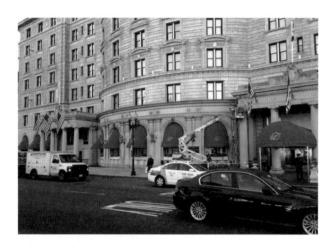

THE FIRST THREE SHOTS say it all: aspiring young lawyer Mitch McDeere (Tom Cruise) stands at a bus stop and looks across the street. Cut to a point-of-view shot that reveals the Copley Plaza Hotel. The hotel is a big structure, and Mitch's view can only take in the facade of the entrance area, including the hotel's iconic red awnings. Cut back to Mitch now slowly moving his head upwards to take in the entirety of the building. Designed by Henry Janeway Hardenbergh and opened in 1912, the Copley Plaza still stands as a Boston landmark for the city's rich history and elegance. US presidents and royalty from around the world have been guests there. This history is communicated in Mitch's behaviour: he is aware of the grand building he is about to set foot in for the potentially most important job interview of his life – a well-chosen location for the story's purpose. While only a fraction of the Grand Ballroom – with its chandeliers and intricate ornate wall features – is revealed two shots later when Mitch enters the hotel, the majority of its iconic elements are not shown or emphasized (such as the 5,000 square-foot lobby and the double 'P' monogram for its sister hotel, The Plaza in New York City). The rule that 'less is sometimes more' is perfectly demonstrated. The magnificence of the Copley Plaza Hotel cannot be fully communicated on film; thus, a personal visit is necessary. ↦ **Monika Raesch**

Photo © Edward Eaton

Directed by Sydney Pollack
Scene description: A young lawyer visits the Copley Plaza Hotel for a job interview
Timecode for scene: 0:02:14 – 0:02:39

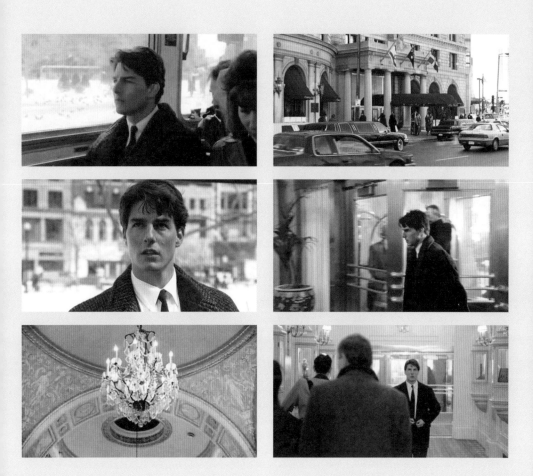

BLOWN AWAY (1992)

LOCATION *Copley Square, 560 Boylston St*

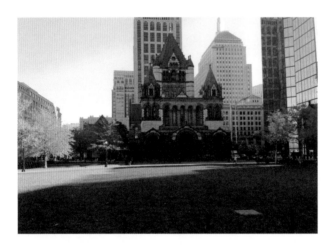

WHAT HAPPENS WHEN Old World notions collide with New World sensibilities? According to the 1994 film *Blown Away*, the result is volatile. *Blown Away* begins in Ireland with the prison escape of terrorist Ryan Gaerity (Tommy Lee Jones). It then switches to Boston, where bomb-squad member Jimmy Dove (Jeff Bridges) discovers that his past isn't quite finished with him: Gaerity has come to Boston seeking revenge against his former protégé. With a flair for the dramatic, Gaerity sets up Copley Square as the stage for the revelation of his plans. With its own blend of old and new, Copley Square proves an ideal place for exploring the theme of a colliding past and present. *Blown Away* emphasizes the location's own anachronistic nature by transitioning from a shot of the sleek, modern lines of the John Hancock Tower into an aerial shot of the adjacent historical Trinity Church. Jarringly quick multi-angle camera shots mimic the chaotic reunion of Dove's old and new worlds. The scene toggles between narrative past and present as the blast of Gaerity's bomb triggers a flashback sequence. Moments later a ringing cellphone delivers the ultimate clash of forces as Dove discovers that his family is Gaerity's next target. Dove eventually rescues his family, but this climacteric scene, set within such an iconic site, is not soon forgotten. Through its masterful use of Copley Square, *Blown Away* proves that, if used effectively, the right film location can truly be explosive.

•❖Katherine A. Wagner

Photo © Edward Eaton

Directed by Stephen Hopkins
Scene description: Explosion of Bomb Squad Van
Timecode for scene: 0:44:35 – 0:52:33

WITH HONORS (1994)

LOCATION *Boston Athenaeum, 10½ Beacon Street*

AS HARVARD UNIVERSITY rarely grants permission to shoot on its grounds, other localities have to double for the Ivy League university. In this film, the Boston Athenaeum doubles as Widener Library. It is itself one of the oldest libraries in the country. Former Harvard drop-out, biographer, poet and dramatist Gamaliel Bradford wrote in 1931: 'It is safe to say that [no library] anywhere has more an atmosphere of its own, that none is more conducive to intellectual aspiration and spiritual peace [than the Boston Athenaeum].' The film's homeless character Simon Wilder shares, 'this library is like a church.' The establishing shots of the building's ground floor reveal high ceilings, archways and sculptures, creating a beautiful yet understated elegance. The contrast between the less fortunate populations with an elegant building recalls the timeless question whether the two can harmoniously co-exist. Shortly after entering the building, Wilder is asked to leave, suggesting an answer. In the film's climax, Harvard student Monty Kessler, who befriended Wilder, visits the library to return *Leaves of Grass* (1855) by Walt Whitman – a social outcast himself. Being fired from his job due to the book's 'obscene' content, today, 'Song of Myself' is viewed as one of the most acclaimed American poems. Looking at the grandiose hall in which he has studied, Monty smiles, implying that he has learned priceless lessons regarding someone's worth, as he is about to graduate with*out* honours. The Athenaeum seamlessly blends in with the university it represents, and Whitman's book functions as a perfect prop. **➳Monika Raesch**

Directed by Alek Keshishian
Scene description: *Harvard student Monty Kessler invites homeless man Simon Wilder*
to join him in the library. Once inside, a staff member asks Wilder to leave
Timecode for scene: *0:27:19 – 0:30:26*

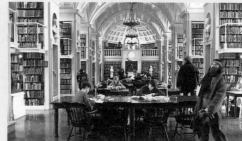
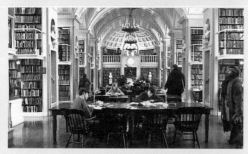

CELTIC PRIDE (1996)

LOCATION *Boston Garden, 150 Causeway Street (now TD Garden,100 Legends Way)*

BOSTON IS THE sports hub of New England and quite successful in many sports: Red Sox (baseball – recently triumphing at the 2013 World Series, held in Boston's own Fenway Park), Patriots (football), Bruins (ice hockey), Celtics (basketball). It is not surprising that a movie homage to one of these teams transpired in 1996. Equally unsurprising is that the game action was shot on-location in the Boston Garden, the arena that was home to the Celtics and the Bruins for many years. The dynasty of both teams is introduced when we first enter the arena for Game 6 of the NBA World Championship: Celtics fans Mike and Jimmy are in awe of the arena; and the shots of the Garden's ceiling features the many championship banners of both teams. Mike declares 'a new Celtics dynasty is about to begin', hoping his team will win the game. He wears a #33 jersey, representing Larry Bird, the most iconic Celtics player. Bird played his entire professional career for the Celtics (1978–92), won three NBA world championships, two NBA Finals MVP awards, was a twelve-time NBA All Star, and honoured MVP of the league three times. The fans in the Garden are decked out with fan memorabilia and the crowd scenes illustrate the passion of real Celtics fans. Albeit, no new Celtics dynasty was about to begin at the conclusion of this film ... and also the Garden, built in 1928, had to fall eventually, as is visualized during the closing credits. Yet this demolition is a sham as the building was demolished in 1998, two years after *Celtic Pride*.

➻Monika Raesch

Photo © Ken Martin / Amstockphoto.com

Directed by Tom DeCerchio
Scene description: Game 6 of the NBA World Championship; Garden Building Demolition
Timecode for scene: 0:9:58 – 0:21:15 and 1:29:25 – 1:30:21

Images © 1996 Caravan Pictures/Hollywood Pictures

AMISTAD (1997)

Massachusetts State House, 24 Beacon Street

ANOTHER FILM BASED on a true story, yet many locations double for the locations where the historical events actually occurred. The Massachusetts State House doubles as the US House of Representatives. The movie's debate scene was shot in the MA Senate Reception Room, the chamber scene was filmed in the MA House of Representatives. The building's most powerful shot is one in almost complete darkness though and is used to transition from the previous day's closing statement by John Quincy Adams to the announcement of the verdict. We see Adams slowly pacing a hall, implying the importance of the upcoming decision. He is walking in the MA State House's circular Memorial Hall. In the background, one sees three archways, which connect to the Nurses Hall with two marble staircases on either side and an unidentifiable statue on the left, and Bartlett Hall behind, with the statue of W.F. Bartlett – a volunteer for the Union Army during the Civil War who became a major general – at the back wall. The statue on the left is the Army Nurses' Memorial, commemorating the nurses' efforts during the Civil War. As the scene takes place in the early morning hours, no such informative details of the rooms can be identified, which is essential for the stand-in location not to be apparent. In this sparse light, the rooms look majestic and reflect the historic decisions being made inside such a building. The orange and bluish lighting design beautifully brings out the colours of the marble floors and staircases and sets the hopeful mood for the Africans to be freed.

◆ Monika Raesch

Photo © Edward Eaton

Directed by Steven Spielberg
Scene description: Man walking outside of courtroom, awaiting verdict
Timecode for scene: 2:18:49 – 2:19:00

POST-HUMAN BOSTONIANS

States of Being in Boston Sci-Fi Films

Text by
HENRI-SIMON
BLANC-
HOÀNG

SINCE THE 1960S, numerous science fiction films have used Boston as a backdrop for exploring the post-human condition: whether an environment with cyborgs and mutants, a world where mankind is extinct, or exploring brain enhancement, theories of unconscious mind and Darwinian evolution. Such films urge viewers to contemplate the advantages/crises of life at the twilight of human experience.

In *Coma* (Michael Crichton, 1978), based on Robin Cook's 1977 novel, Dr Susan Wheeler (Genevieve Bujold) of the fictional Boston Memorial Hospital (a composite of Boston City Hospital and Massachusetts General Hospital) discovers that a colleague is inducing comas in his patients. With advanced technology, his victims' comatose bodies are maintained in stasis, allowing him to keep their organs fresh and ready for use. This film anticipates a dystopian world where those who can afford it are allowed to live indefinitely, while others' bodies will be harvested for organs. This film forces us to ask whether the unconscious bodies of the victimized comatose patients cannibalized for their parts are still 'human'.

If our bodies (and their physical limitations) are what define us as human beings, what should we call Bostonians who live through remote-controlled androids in Jonathan Mostow's 2009 *Surrogates*?

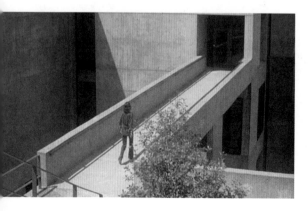

In *Surrogates*'s futuristic world, Bostonians delegate their daily tasks to their (more glamorous) stand-ins, allowing them to stay at home all day, dishevelled and frumpy. A mad scientist invents a system to simultaneously kill *both* the androids and their users. Near the film's conclusion, FBI agent Tom Greer (Bruce Willis) must break into the Boston mansion of the surrogates' billionaire developer – the mad scientist himself – to keep him from killing those using his invention. While exploring the pitfalls of technology, this film reveals the risk in our ever-increasing desire for physical perfection.

Charly (Ralph Nelson, 1968), adapted from Daniel Keyes's 1959 novel *Flowers for Algernon*, is an early look at the post-human condition. A mentally challenged man, Charly (Best Actor Oscar-winner Cliff Robertson) undergoes experimental surgery, 'curing' his mental deficiency beyond his doctors' best hopes. Earlier, it is revealed that Charly took a weekly bus tour of Boston, but could not remember the facts narrated by the guide. After his surgery, Charly is not interested in the simple life he led; instead, he pursues academic disciplines. However, the 'cure' is not permanent. By the film's end, Charly has regressed to his previous state. While exploring post-human possibilities, *Charly* is about human limitations: Charly, limited by his below average mental capacity; and the doctor, whose ability to 'cure' Charly is limited by science. *Charly* interrogates society's obsession with 'normality' and our fear of what – and who – is perceived as 'abnormal'. Is abnormality synonymous with lack of humanity (at least, on an unconscious level)?

Darwinian evolution is a topic associated with post-humanity. In *Altered States* (Ken Russell, 1980), Eddie Jessup (William Hurt), a research scientist at Harvard Medical School, combines an old mind-altering 'technology' (peyote) with a new one (an immersion tank), thereby accessing humanity's collective unconscious. Jessup mentally and physiologically (through temporary transformations) re-lives every step of human evolution. This film raises questions about what makes us human and

Above © 1980 ABC Pictures, Robertson and Associates
Opposite © 1978 ABC Pictures, Robertson and Associates

who takes our place after humanity's extinction.

The Handmaid's Tale, Volker Schlöndorff's 1990 cinematic adaptation of Margaret Atwood's eponymous novel, set in the not-too-distant future, explores the extinction of the white race due to infertility. In the Republic of Gilead (formerly the United States), the few Caucasian women capable of bearing children are treated as surrogate wombs ('handmaids') by those in power. Handmaids are denied sexual pleasure and any found 'guilty of fornication' are executed in Harvard Yard. Of course, condoning sex as only a means of reproduction is typical of a repressive totalitarian state. That privileged wannabe-mothers could one day use 'laptop' wombs (handmaids) is a post-human concept. It goes without saying that this environment is not desirable for the future; this narrative falls within the dystopian genre.

In *The Box* (Richard Kelly, 2009), another famous centre of knowledge, the Boston Public Library, is linked to the possibility of the human race being wiped out. Mysterious beings put humankind through an ethical trial: selected individuals are offered 1 million dollars, but the 'price' for this gift is the death of another human being whom they do not know. If the test is failed, 'those who control the lightning' will exterminate humankind. A married couple attempts to learn more at the Boston Public Library. Instead, they discover that this is the operations centre for 'those who control the lightning' who send the humans who fail the test

In *Surrogates*'s futuristic world, Bostonians delegate their daily tasks to their (more glamorous) stand-ins, allowing them to stay at home all day, dishevelled and frumpy.

to an unknown location. In this film, a post-human world is a utopian Earth without 'greedy' humans.

In Steven Spielberg's version of *War of the Worlds* (2005), aliens living beneath the surface of the Earth also 'control the lightning', bringing life to their pods. When the alien invasion begins, humankind faces extinction. Ray Ferrier (Tom Cruise) flees Jersey City to save his family in Boston. Although the technology produced by the military-industrial complex is powerless against the aliens, the army seems to have held its ground in Boston (filmed in Connecticut and Brooklyn). When Ferrier reaches his destination, a human virus has wiped out the *intra-terrestrials*. Ironically, it is a virus, which humans view as a pest to be exterminated – mirroring the aliens' view of humans – that saves humanity. In this case, a post-human Earth has been delayed.

In *The Core* (Jon Amiel, 2003), the deterioration of Earth's electromagnetic pulse represents another threat from beneath our planet's surface. The opening scene of the movie shows the consequence of this terrifying discovery: in downtown Boston, those with pacemakers drop dead. The military-industrial complex brings an elite team of scientists together into its secret Boston facilities. The team travels to the Earth's core aboard a subterranean vessel to fix our planet's electromagnetic pulse. In this scenario, the advent of post-humanity (when humankind ceases to exist) will again have to wait.

The fear that a more advanced race will replace *Homo sapiens* fuels the mutant-phobia that drives the X-Men films. In *X-Men 2* (Bryan Singer, 2003), Snow (Hally Berry), a mutant, travels to an abandoned Boston church (in reality, Vancouver) to find another mutant who is suspected of the attempted assassination of the US president. That an abandoned church becomes a shelter for a post-human fugitive is not a coincidence. Since humans often turn to religion when faced with something they do not understand, this mutant escapes persecution by finding sanctuary in a house of worship. We are faced with the question of whether a post-*Homo sapiens* species can be accepted as one of us.

The Boston locations of these narratives relate to the scientific/academic world: college campuses, libraries, university hospitals, for-profit research institutions (supported by the corporate world or the military-industrial complex). Whether anticipating the expansion of human intellect, exploring the unconscious mind, or grappling with human extinction, in these films, the advent of post-humanity will occur in Boston. ✤

LOCATIONS MAP

BOSTON

maps are only to be taken as approximates

BOSTON LOCATIONS
SCENES 25-32

25.
THE MATCHMAKER (1997)
Faneuil Hall, 1 Faneuil Hall Square
page 72

26.
GOOD WILL HUNTING (1997)
Bow Street Dunkin' Donuts
(Harvard Square), 1 Bow Street, Cambridge
page 74

27.
THE SPANISH PRISONER (1998)
Rowes Wharf, Water Transport,
60 Rowes Wharf
page 76

28.
MONUMENT AVE. (1998)
Tobin Bridge
page 78

29.
NEXT STOP WONDERLAND (1998)
Revere Beach, Revere Beach Blvd, Revere
page 80

30.
THE BOONDOCK SAINTS (1999)
The Old Charles Street Jail (called 'The Hoag
Maximum Security Prison' in the film), now
the Liberty Hotel, 215 Charles Street
page 82

31.
ALEX & EMMA (2003)
Boston Public Garden, 69 Beacon Street
page 84

32.
MYSTIC RIVER (2003)
Old Bear Dens, Long Crouch Woods,
Franklin Park, 1 Circuit Drive
page 86

THE MATCHMAKER (1997)

LOCATION

Faneuil Hall, 1 Faneuil Hall Square

ARGUABLY NO BETTER LOCATION could have been chosen for Senator John McGlory's (his name provides an additional humorous touch) victory speech following his senatorial re-election in this romantic comedy. He stands in Faneuil Hall, where Samuel Adams once took to the podium. The Hall, also referred to as the 'Cradle of Liberty', was the centre of revolutionary activities and functioned as the government meeting place until approximately 1822. Positioning McGlory here provides audiences the opportunity to assess modern election campaigns by being reminded of past generations' accomplishments. The contrast of this historical setting in a comedic narrative adds a humorous touch. McGlory is standing in front of a painting depicting Daniel Webster during a speech that concerned the union of states given in Washington DC in 1830. In contrast, McGlory's main campaign focus was to win more Irish votes. His 'issue' pales in comparison to the actual events that occurred in Faneuil Hall. His team also features the film's antagonist, Nick, who gets exposed as the man he truly is during the re-election party in front of the paintings that depict heroic former politicians, such as John Hancock and George Washington. Nick will not be added onto the wall. And even in the building's hallways, Boston/American history is ever present: when assistant Marcy descends a staircase, she is walking along cherry wood railing that dates back to 1806. The floors in the Hall are from the end of the nineteenth century. The entire location makes the comedic backstabbing McGlory and his team have been dealing with look like a farce and speak as a silent negative judgment on political campaigning.
◆*Monika Raesch*

Photo © Monika Raesch

Directed by Mark Joffe

Scene description: Election Victory Party at Faneuil Hall

Timecode for scene: 1:27:14 – 1:32:37

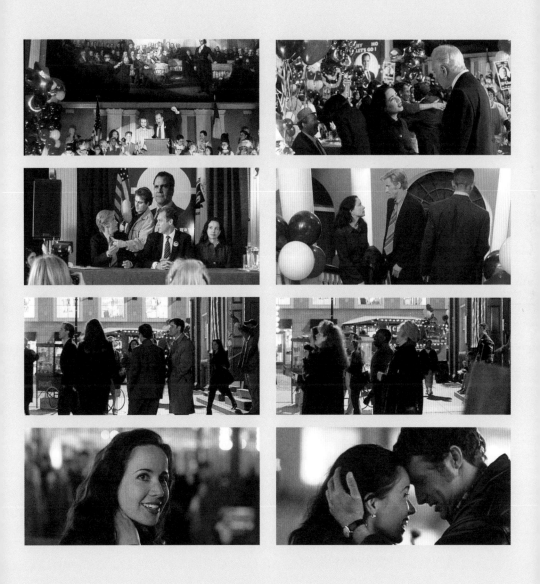

GOOD WILL HUNTING (1997)

LOCATION *Bow Street Dunkin' Donuts (Harvard Square), 1 Bow Street, Cambridge*

WILL HUNTING (Matt Damon) and his small group of working-class friends spend the evening in a bar near Harvard Square, drinking, flirting and looking for trouble. They find the latter in an arrogant graduate student who seeks to humiliate Will's best friend, Chuckie (Ben Affleck). Although he lacks a formal education, Will is a genius, turning the tables on the graduate student and in so doing attracting the attention of Skylar (Minnie Driver), a Harvard undergraduate. Later that evening, as Matt walks down Bow Street with his friends, he spots the graduate student sitting in a Dunkin' Donuts, taking the opportunity to taunt him through the window. This scene serves as a microcosm of the film. Will is a brash, angry product of the foster-care system, and due to his irresponsible behaviour can barely hold down his janitorial job. However, he is also a genius, solving equations placed upon the bulletin boards at MIT while he takes breaks from mopping the floor. In short, Will does not fit in anywhere; he has way more potential than his South Boston friends but lacks the background or refinement to thrive in a Harvard-type atmosphere. Two worlds collide on Bow Street, and Will finds himself at a crossroads. An award-winning mathematician (Stellan Skarsgard) and a caring psychiatrist (Robin Williams) will help him negotiate the new path he finds himself on, but ultimately Will himself must determine the best course for his future. **⊷Andrew Howe**

Photo © Edward Eaton

Directed by Gus Van Sant
Scene description: Will and friends visit Cambridge
Timecode for scene: 0:21:26 – 0:22:07

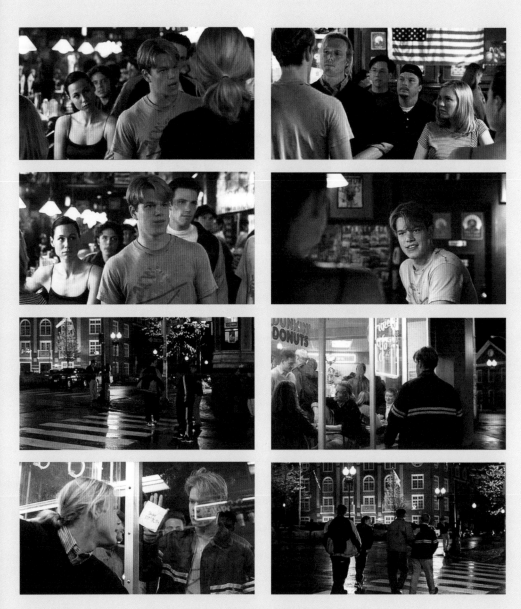

Images © 1997 Be Gentlemen Limited Partnership/Lawrence Bender Productions/Miramax Films

THE SPANISH PRISONER (1998)

LOCATION *Rowes Wharf, Water Transport, 60 Rowes Wharf*

DAVID MAMET'S SUSPENSE FILM can easily be called serpentine. It is perhaps needlessly complicated. Mamet certainly jumps through a lot of hoops and stretches credulity to its breaking point in his effort to get innocent, yet fugitive, Joe Ross (Campbell Scott) and co-worker Susan (Rebecca Pigeon) from New York City to Boston. First, they drive to Logan Airport (because the New York police will be on the lookout for suspected murderer Joe), and then ride on the water taxi, where Susan and Jimmy Dell (Steve Martin) try to kill Joe. After Jimmy and Susan are arrested by the US Marshals, they are taken onto the wharf itself. There, Susan calls out to Joe for help. 'Can I be your good deed for the day?' she begs. This plea is all but inexplicable: they hardly have any sort of relationship beyond some rather strained and untitillating dialogues that can barely be called conversations, much less flirtations; she has just tried to have Joe killed. By this time, Joe has learned that not only are Jimmy, the FBI team and Susan part of the elaborate confidence game but also that the ringleader of the group was his boss, Mr Klein (Ben Gazzara). Joe's response to Susan of 'I'm afraid you're gonna to have to spend some time in your room' is unsatisfactory, as is the ending to his journey. As a character, he has not grown. Nor has he succeeded in finding the location of the stolen process (Jimmy's explanation of having sold it to Switzerland is painfully vague). In the background of this scene, one can see the John Joseph Moakley Federal Courthouse, which was under construction at the time. One gets the impression from the film – and from its disappointing end – that it, like the Moakley Federal Courthouse, is a work in progress, not the finished article.

✦*Edward Eaton*

Photo © Karen Ladany

Directed by David Mamet
Scene description: Joe Ross watches as Jimmy Dell and Susan are arrested and taken away
Timecode for scene: 1:44:15 – 1:44:43

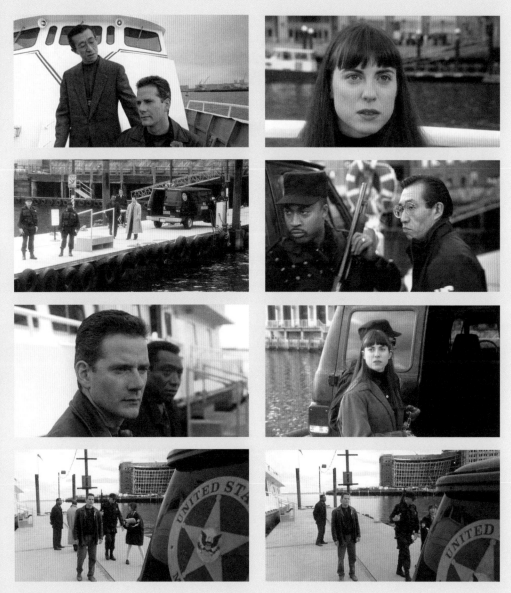

MONUMENT AVE. (1998)

LOCATION *Tobin Bridge*

AFTER A NIGHT OF DRINKING AND MAYHEM, Bobby (Denis Leary) argues with his Irish cousin Seamus (Jason Barry), who plans to return to Dublin. The cousins are car thieves for paranoid crime boss Jackie O'Hara (Colm Meaney), who callously has a friend of Bobby's murdered in front of him. As the cousins argue, the Tobin Bridge – which connects the Boston neighbourhood of Charlestown to the city of Chelsea – is visible in the background. This bridge, which spans the Mystic River, symbolizes Bobby's extreme provincialism, as for him Boston is just about the entirety of his world. This point is driven home by Detective Hanlon (Martin Sheen), who echoes Seamus in noting that working for O'Hara will not end well, and who equates the bridge to a form of escape. For Hanlon, Bobby crossing over entails testifying against O'Hara. Despite his growing unease with his boss, Bobby lives by a code and will not consider this course of action. When O'Hara has Seamus murdered, however, the situation becomes untenable and Bobby is indeed faced with a dilemma: should he continue to work for O'Hara, who may grow to distrust Bobby and have him killed, or should he cross the bridge as a means of escape, leaving behind his family and friends and the only world he has ever known? Neither of these solutions is acceptable to Bobby, leading him to consider a third alternative, one that might just allow him to stay in his community while simultaneously ensuring his safety. **◆ Andrew Howe**

Photo © Karen Ladany

Directed by Ted Demme
Scene description: Bobby Argues with his cousin
Timecode for scene: 0:56:54 – 0:58:45

NEXT STOP WONDERLAND (1998)

LOCATION *Revere Beach, Revere Beach Blvd, Revere*

NOMINATED FOR THE Grand Jury Prize at Sundance, *Next Stop Wonderland* is an indie romantic-comedy about fate and the hidden poetry of the everyday. Erin (Hope Davis) is depressed, partially because of the sudden departure of her activist boyfriend, Sean (Philip Seymour Hoffman), who gives her a VHS that explains the six ways he felt their relationship was doomed. But mainly Erin is still mourning the death of her beloved father. Concerned, Erin's mother (Holland Taylor) places a personal ad for her, which gets Erin out of the house on a series of horrifyingly bad dates. It also brings her closer and closer to love and fate in the form of Alan (Alan Gelfant), an ex-plumber studying to become a marine biologist. In the last minutes of the film, Erin, overwhelmed by the crush on the MBTA Blue line, doesn't get off at the airport to fly to Brazil, but collapses into Alan's arms instead. They ride the train to its final stop, Wonderland, and walk to Revere Beach. Revere Beach, founded in 1895, was the first public beach in the nation. For early visitors, Revere beach was full of attractions: the Ocean Pier with its dance pavilion, cafe and skating rink, and huge Wonderland Park with its roller coasters, parades and Wonderland Ballroom. The magic of Wonderland Park (replaced by the Wonderland dog track) is gone, but the beautiful public beach remains. After Erin catches her breath, she and Alan take a walk on the sand together.
↝Kristiina Hackel

Photo © Karen Ladany

Directed by Brad Anderson
Scene description: Erin and Alan discuss life philosophies and take a walk on the beach
Timecode for scene: 1:29:15 – 1:31:46

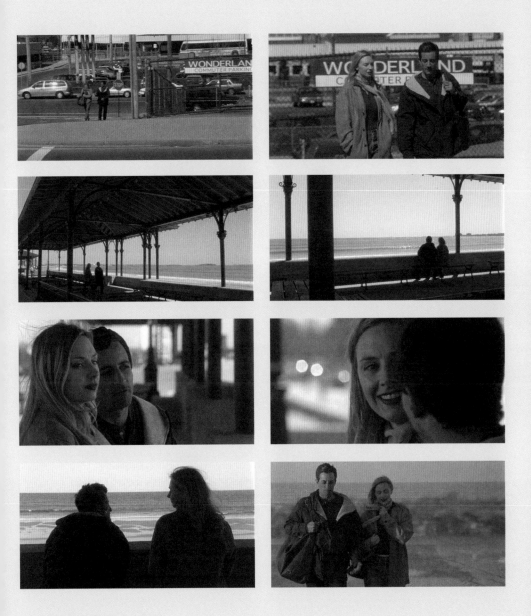

THE BOONDOCK SAINTS (1999)

LOCATION

The Old Charles Street Jail (called 'The Hoag Maximum Security Prison' in the film), now the Liberty Hotel, 215 Charles Street

A GOOFY FILM by first time writer and director Troy Duffy, *The Boondock Saints* had a limited release but became a cult favourite on DVD, especially among the millennial college population. The story is simple: when three Russian goons try to shut down their bar on Saint Patrick's Day, the McManus twins (Sean Patrick Flanery and Norman Reedus) kill two of them. That night, they have a vision of holy water pouring from the ceiling of their jail cell, and they understand it's time for a righteous killing crusade. Their targets: all bad guys in Boston. Duffy is aiming for something Tarantino-esque, but he doesn't have Tarantino's style or cool. In Duffy's hands, even potentially interesting characters – like FBI Agent Smecker (William Dafoe) who likes to conduct Italian operas as he re-enacts crime scenes – come across as wacky and hyperbolic.In this scene, the legendary killer Il Duce (Billy Connolly) is released from the fictional Hoag Maximum Security Prison by the mafia crime boss Yakavetta to eliminate the McManus brothers. The prison is actually the Old Charles Street Jail, which was built in the shape of a cross (most appropriately for this film) in 1851. During more than a century of operation, the Charles Street Jail held a number of famous prisoners including Sacco and Vanzetti. The jail is now converted to the luxurious Liberty Hotel which features bars with cute names like Clink, which incorporates old cells, and Alibi, which takes advantage of the old drunk tank.
➥*Kristiina Hackel*

Photo © Ken Martin / Amstockphoto.com

Directed by Troy Duffy

Scene description: Il Duce is released from prison to kill the McManus brothers

Timecode for scene: 1:09:17 – 1:11:25

Images © 1999 Franchise Pictures/Brood Syndicate

ALEX & EMMA (2003)

Boston Public Garden, 69 Beacon Street

IN THIS FILM INSPIRED by Fyodor Dostoevsky's *The Gambler* – as well as the circumstances behind that novel's genesis – Alex (Luke Wilson) is saddled with writer's block and desperately needs stenographer Emma (Kate Hudson) to help him complete in 30 days the novel that he has not even started. This will enable him to earn the $100,000 to pay back the thugs who violently threatened him and burned his laptop in the opening scene. The film alternates between scenes of their collaborations and scenes from the novel in progress. Most of the film's action takes place in Alex's apartment, but in this scene, having written his characters into a corner, he and Emma take a well-deserved break for fresh air and inspiration. In this montage, with Norah Jones's 'Those Sweet Words' (2004) playing, which incidentally almost became the title of the film, they walk past one of the Public Garden's famed Swan Boats, toss around a football, and peruse books at a bookseller situated near the Boston Irish Famine Memorial, at the corner of Washington and School Streets. Alex is visibly annoyed with Emma's habit of reading the endings of books to see if she wants to read the rest. They conclude their outing by riding a Boston Duck Tours boat and walking along the Charles River. À la *The Wizard of Oz* (Victor Fleming, 1939), the characters in the real world all have their doppelgänger counterparts in the Gatsbyesque *mise en abyme*, and this scene will be mirrored soon after with Adam and Anna growing closer together over ice cream, just as Alex and Emma do in this scene. Alex decides to no longer live vicariously through the romances of his semiautobiographical protagonists. **•>Zachary Ingle**

Photo © Edward Eaton

Directed by Rob Reiner
Scene description: Taking a break from writing
Timecode for scene: 0:52:46 – 0:53:29

MYSTIC RIVER (2003)

LOCATION

Old Bear Dens, Long Crouch Woods, Franklin Park, 1 Circuit Drive

WITH SEXUAL ABUSE and an unresolved trauma that have overshadowed their lives, three former childhood friends are reunited by circumstance in a tightknit blue-collar Boston neighbourhood some decades later, when the beloved adolescent daughter of one of the men, Jimmy Markum (Sean Penn), goes missing. The two other former friends, Sean Devine (Kevin Bacon) and Dave Boyle (Tim Robbins), happen to be, respectively, lead police detective on the case and a suspect in the crime. As the Boston police's helicopter search eventually turns up the victim's body half buried in the underbrush of a circular old bear den within the green thicket of Franklin Park, framed by iron cages and large gates and at the intersections of three Boston neighbourhoods – Dorchester, Jamaica Plain and Roxbury – the plot develops, winding around the question of whether their earlier friendship can withstand the rigours of deception, murder and betrayal. The deteriorated location where Katie's body is found is an area notoriously used for illicit activities and illegal dumping. This scene marks a pivotal point in a multi-layered story that has to be unravelled over more than one generation, since the taking of Katie Markum's life is fatally connected to brutal murders in the past as well as in the near future. These are described as humankind's darkest and wildest emotions triggered by love and fear. Tight family relationships, psychological trauma and machismo in small neighbourhoods seem to lead into never-ending uncontrollable rage, vigilantism and revenge. Yet, in *Mystic River* they are literally justified with the saying 'We bury our sins, we wash them clean'. •**Pamela C. Scorzin**

Directed by Clint Eastwood
Scene description: Katie is found murdered
Timecode for scene: 0:31:24 – 0:34:06

FENWAY PARK

Text by
ZACHARY
INGLE

The Green Monster on the Silver Screen

THERE ARE OLDER baseball teams than the Boston Red Sox (who began in 1901 as a founding franchise of the American League), but few are as famous. Until recently, the Red Sox were primarily known for losing the World Series (1946, 1967, 1975, 1986) before finally winning in 2004, their first victory since 1918, when Babe Ruth pitched. Shortly thereafter, Ruth was sold to the New York Yankees, who subsequently won 27 championships, a shift in fortunes known as the 'Curse of the Bambino'.

Opening for the 1912 season, Fenway Park is the oldest Major League stadium still in use. Located at 4 Yawkey Way in Boston's Fenway-Kenmore neighbourhood, the most famous feature of the Red Sox's home is the 'Green Monster', the wall over 37 feet high – the tallest in Major League Baseball – in left field, making it more difficult for home runs to clear. Fenway Park is one of baseball's 'cathedrals', rivalled only by the Chicago Cubs's Wrigley Field for a ballpark still in use.

Several baseball films have exploited Fenway Park's iconicity, although this is a relatively new trend, perhaps beginning with the 'Moonlight Graham' scene from *Field of Dreams* (Phil Alden Robinson, 1989), discussed elsewhere in this

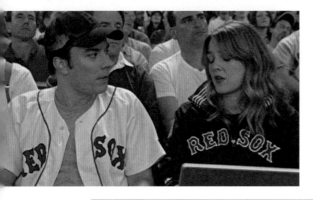

volume. Before this film, Fenway was almost never represented on-screen. In *The Babe Ruth Story* (Roy Del Ruth, 1948), the biopic most extensively treating Ruth's time with the Sox, only the exterior of the stadium appears in two establishing shots. The second major Ruth biopic, *The Babe* (Arthur Hiller, 1992) features fewer scenes in its recreation of Fenway Park. A Minor League stadium in Danville, Illinois was used as its 'body double' since Fenway Park in the early 1990s looked drastically different than it did when Ruth played there. *Fear Strikes Out* (Robert Mulligan, 1957), a biopic of Sox outfielder Jimmy Piersall, also failed to include authentic stadium locations. Stock footage of Fenway Park is awkwardly inserted while the filming occurred at another Minor League park, the 'other' Wrigley Field in Los Angeles, a popular location for 1940s/1950s baseball films.

After *Field of Dreams*, non-period baseball films were better able to feature the location. *Little Big League* (Andrew Scheinman, 1994) rarely leaves the Metrodome, home of its featured ballclub, the Minnesota Twins, but does include a brief scene at Fenway. Based on a true story, *Moneyball* (Bennett Miller, 2011) features sabermetric guru Billy Beane (Brad Pitt), manager of the Oakland Athletics, visiting an empty Fenway Park to speak with Red Sox owner John Henry, who attempts to lure the now successful Beane away from the Athletics.

A Boston icon, Fenway is often featured as a memorable film location, even sans baseball action. Fenway Park appears in the climaxes of *The Town* (Ben Affleck, 2010) and *Ted* (Seth MacFarlane, 2012). In *The Town*, focusing on a gang of Charlestown bank robbers, the film's final heist is their biggest yet: their target is the 'cathedral of Boston' as they try to rob the stadium's gate receipts. This film-scene stands out among others set in Fenway Park, as the action is

Opposite *Fever Pitch* (2005) / **Below** *Field of Dreams* (1989)

Above © 1989 Gordon Company
Opposite © 2005 Fox 2000 Pictures, Flower Films (II)

not on the field or in the stands, but rather, in the bowels of the stadium. Seth MacFarlane, who called Fenway 'a great playground', showcased some of these corridors and passageways in *Ted*, although the main action takes place in the outfield bleachers and light tower above the Green Monster.

No film has featured Fenway Park more prominently and reverently than the Farrelly brothers' paean to their beloved Sox, *Fever Pitch* (2005), supposedly the first production allowed to film during an actual game (unlike the simulated game in *A Civil Action* [Steven Zaillian, 1998]). The opening scene of this romantic comedy shows morose 7-year-old Ben sitting on his couch, circa 1980. His uncle then takes him to his first game at Fenway, where he has season tickets right behind the Sox dugout on the first base side. Ben is intrigued by the Green Monster, the Red Sox win, and, 'By day's end, poor Ben had become one of God's most pathetic creatures – a Red Sox fan'. This experience has such a profound impact on the impressionable young boy that, as an adult, Ben's (Jimmy Fallon) life revolves around the Red Sox, attending all 81 yearly games at Fenway in the prime seats he inherited from his uncle.

Ben's fanaticism borders on obsession, hindering his ability to have a stable romantic relationship, but he falls for Lindsey (Drew Barrymore), a workaholic who initially tolerates his passion for the Sox. Ben takes her to opening day of the season, and Lindsey makes a go of it, trying to learn the game and the history of the Red Sox. There are several scenes at Fenway, including rituals such as the crowd singing Neil Diamond's 'Sweet Caroline', and shots that include actual Red Sox players. As the season wears on, she becomes less interested and busier with work, bringing her laptop to one game before getting clobbered by a foul ball. Ben considers selling his seats, but Lindsey realizes the sacrifice he is making for her and that he has prioritized her over his beloved Red Sox. During the seventh game of the 2004 American League Classic, Lindsey drops down from the centrefield fence and races across the field to Ben with security guards chasing after her, ultimately stopping him with the promise to, together, 'jerk one out of the park'.

In 2004, the Red Sox were down in the ninth inning, and even worse, down three games to none in the series, a seemingly insurmountable disadvantage from which no team in Major League Baseball's history had ever recovered. (The best documentary treatment of this series is ESPN's *Four Days in October* [Gary Waksman, 2010] and Ken Burns's *The Tenth Inning* [2010].) That the Red Sox would actually win a World Series that year was so unexpected that a new ending was added to *Fever Pitch*, where Lindsey and Ben run onto the field at Busch Memorial Stadium in St Louis after the Red Sox swept the Cardinals in four games.

After this memorable postseason, the Red Sox have continued being successful, apparently reversing the Curse, winning the World Series again in 2007 and, most recently, in 2013, clinching this latest championship on their home field of Fenway Park for the first time since 1918. As long as it stands, Fenway Park remains a Boston landmark, as it has been for over 100 years. ✠

A Boston icon, Fenway is often featured as a memorable film location, even sans baseball action.

89

LOCATIONS MAP

BOSTON

maps are only to be taken as approximates

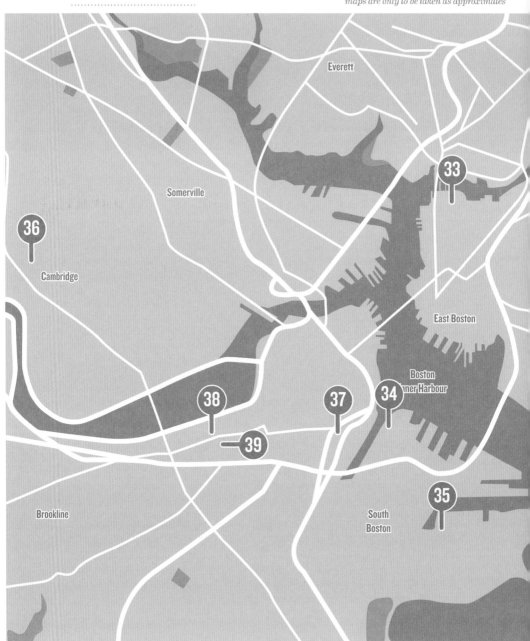

BOSTON LOCATIONS
SCENES 33-39

Revere

Winthrop

Boston
Harbour

33.
FEVER PITCH (2005)
East Boston High School, 86 White Street
page 92

34.
THE DEPARTED (2006)
Rooftop at Fort Point, 12 Farnsworth Street
page 94

35.
GONE BABY GONE (2007)
Murphy's Law Bar, 837 Summer Street
page 96

36.
THE GREAT DEBATERS (2007)
Sanders Theater, Harvard University, 1350
Massachusetts Ave., Cambridge
page 98

37.
21 (2008)
South Street Diner, 178 Kneeland Street
page 100

38.
MY BEST FRIEND'S GIRL (2008)
Old South Church, 645 Boylston Street
page 102

39.
THE BOX (2010)
Boston Public Library, 700 Boylston Street
page 104

FEVER PITCH (2005)

East Boston High School, 86 White Street

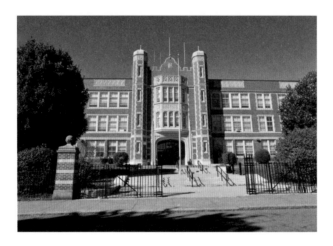

THIS ADAPTATION OF Nick Hornby's autobiographical treatise of Arsenal fandom was originally filmed in 1997 (David Evans, starring Colin Firth and Ruth Gemmell), but UK soccer fever translated well to US baseball fever in one of the Farrelly brothers' most endearing films. This, their paean to their beloved Boston Red Sox, is one of the few baseball films from the fans' perspective, rather than the players. In this pivotal scene, Lindsey (Drew Barrymore) visits Ben (Jimmy Fallon) at his workplace, East Boston High School (built in 1926), where he teaches math. She informs him that she is going to Paris that weekend for a business trip and wants to take him with her. Ben is visibly excited until he realizes that he would have to miss a Red Sox home game, something he has not done in over a decade. This infuriates Lindsey: 'A tip, Ben. When your girlfriend says let's go to Paris for the weekend, you go!' They step outside of his classroom, where students are, ironically, playing soccer in the background. She drops another bombshell: she may be pregnant. Although Lindsey seemingly understands, she realizes where she lies on Ben's priority list – for now. In the end, everything turns out as we would expect in a sports film/romantic comedy. The Farrelly brothers caught lightning in a bottle as the Red Sox, who were on an 86-year drought of World Series championships, actually won one in 2004 (the year they were filming), while Ben finally discovers something even more important to him than his Red Sox. ➻*Zachary Ingle*

Photo © Ken Martin / Amstockphoto.com

Directed by Bobby and Peter Farrelly

Scene description: Ben's passion for the Red Sox threatens to destroy his relationship
Timecode for scene: 0:56:53 – 1:02:12

Images © 2005 Fox 2000 Pictures/Flower Films (II)/Wildgaze Films

THE DEPARTED (2006)

LOCATION *Rooftop at Fort Point, 12 Farnsworth Street*

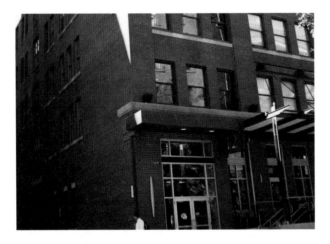

WHEN COSTIGAN (Leonardo DiCaprio) arranges to meet Sullivan (Matt Damon) on the same rooftop from which Queenan (Martin Sheen) was thrown a few scenes earlier, he is making a gesture. It is something of an odd gesture. Certainly, there are better places to make an arrest – especially since Costigan has plenty of hard evidence against Sullivan. Understandably, Costigan wants to make the arrest himself so that he can come in from the cold, but the isolation of the location could easily backfire – as it does. The location is a standard inner-city rooftop. The kind that can be seen in any city in America. What is striking about this location, though, is that it is surrounded by the glittering, shiny skyline of a modern city. The two police officers are on an island of tarpaper in a sea of steel, chrome and glass. The skyline is a short distance from the rooftop, as if the modern city does not want to get too close to the older city. The modern city is rejecting Costigan's vigilantism just as it rejects the old-school mob-style criminal element led, in the film, by Frank Costello (Jack Nicholson). The rooftop is also in the middle of the city, reminding one of the corruption that festers just beneath it. The corrupt Sullivan seemingly will thrive until he is finally brought down by a good cop using corrupt methods. Once, the Fort Point building was new. Someday, the skyline will be old, faded and corrupt. Perhaps, given the corruption that runs through the system that built the gilded city, it will be sooner rather than later. **↦*Edward Eaton***

Photo © Karen Ladany

Directed by Martin Scorsese
Scene description: Costigan confronts Sullivan on the same rooftop from which Queenan was thrown
Timecode for scene:2:16:24 – 2:18:32

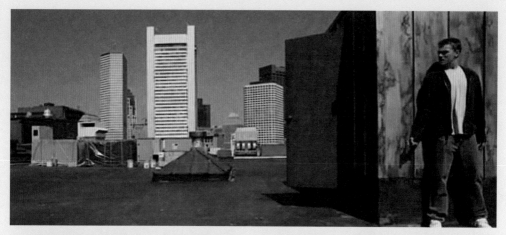

GONE BABY GONE (2007)

Murphy's Law Bar, 837 Summer Street

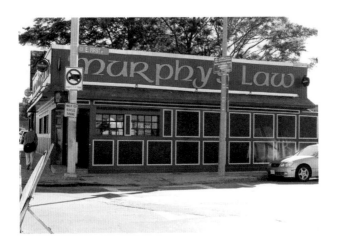

ALTHOUGH SOPHOCLES' *Oedipus Rex* is better known today as the narrative source for Freudian psychoanalytical theory, scholars also consider this play to be the first detective story in the history of literature. An element of this tragedy is found in Ben Affleck's *Gone Baby Gone*, during the scene filmed at Murphy's Law Bar. This part of the movie takes place two months after Patrick Kenzie and Angela Gennaro, a team of private investigators (who are also a couple) close the kidnapping case of Amanda, a child believed to have drowned. Inadvertently, Patrick finds out that officer Remy Bressant not only lied to him during the investigation, but also might have been an accomplice in Amanda's kidnapping. Patrick and Angela then decide to meet Lionel (another suspect who also happens to be Amanda's uncle) at Murphy's Law Bar. Ironically, the name of the place is premonitory since this is where everything begins to go wrong. Fearing that Lionel is about to reveal his involvement in Amanda's disappearance, a disguised Remy shows up at the bar and stages a robbery. The bar owner shoots him before he can kill Lionel. This scene is, in fact, the last time that Patrick and Angela work as a united team. After the police question him about the shootout, Patrick begins to suspect that Jack Doyle, a retired police officer, might be Amanda's kidnapper and is raising her as his own child. Because she believes that Amanda is better off with Jack and his wife, Angela finds herself in the role of Sophocles' Jocasta: she refuses to know the truth about the little girl's fate. Like Jocasta, Angela unsuccessfully begs later her significant other to stop his obsessive investigation before it is too late. **➻Henri-Simon Blanc-Hoàng**

Photo © Karen Ladany

Directed by Ben Affleck
Scene description: Everything begins to unravel
Timecode for scene: 1:21:42 – 1:29:17

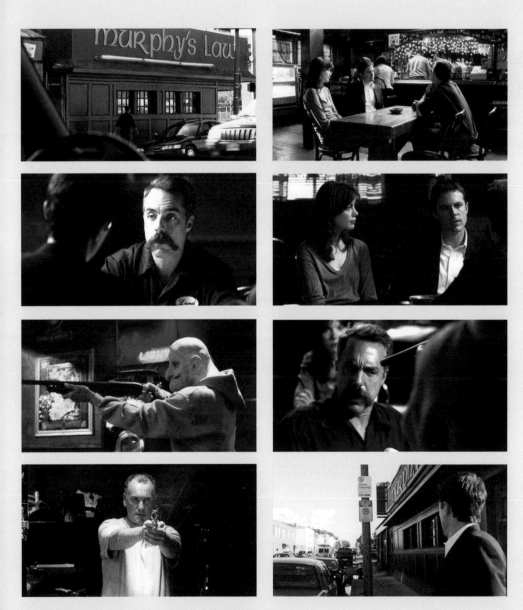

Images © 2007 LivePlanet/Miramax Films/The Ladd Company

THE GREAT DEBATERS (2007)

Sanders Theater, Harvard University, 1350 Massachusetts Ave., Cambridge

THE GREAT DEBATERS is one of the few films that received permission to shoot on the grounds of Harvard University in Cambridge, M.A. Based on the 1935 debate when historically black university Wiley College defeated the University of Southern California (USC), which was then national champion, *The Great Debaters* re-creates this match, but replaces USC with Harvard. Therefore, audiences witness the triumphant Wiley debate team raising the winner's trophy in Harvard's iconic Sanders Theatre. The debate scene opens with a shot at dawn of Harvard's Memorial Hall, home of Sanders Theatre, which was conceived as a memorial for Harvard graduates who had fought in the Civil War. Memorial Hall is shown as a dark building, the sun rising behind it, which adds to the build-up of this momentous occasion. Wiley's Coach Tolson (Denzel Washington) is seen entering and leaving the debate via the Memorial Transept, walking past 28 white marble tablets that bear the names of the Harvard students who lost their lives during the Civil War. The two sequences featuring Sanders Theatre provide many wide shots of its interior space. The first scene in the Theatre takes place when the Wiley College Debate Team visits for the first time; the second scene is the actual debate. This coverage also allows audiences to imagine previous illustrious speakers at the Sanders Theatre podium, including President Theodore Roosevelt and Martin Luther King, Jr.

•• *Monika Raesch*

Photos © Monika Raesch

Directed by Denzel Washington
Scene description: Debate between students from Wiley College and Harvard University
Timecode for scene: 1:33:51 – 1:33:55 and 1:43:39 – 1:57:43

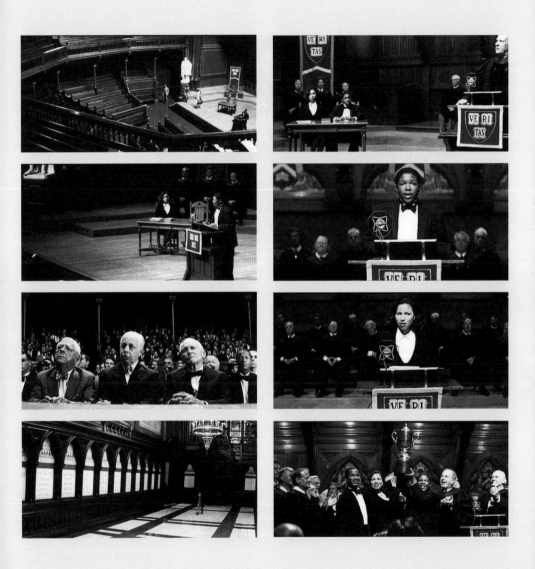

21 (2008)

South Street Diner, 178 Kneeland Street

IN THIS CONSPIRATIONAL diner scene, on a dark and rainy night, MIT senior math major Ben Campbell is recruited and playfully instructed by a math professor's blackjack club on how to win 21 in Vegas. A gifted student group led by their shady academic mastermind, Professor Micky Rosa (Kevin Spacey), departs for Sin City every weekend, armed with the strategic know-how to turn the odds at blackjack in their favour. Brilliant Ben, who cannot afford the tuition for Harvard Medical School and who fatally believes that everything in life depends on having money, at first has his scruples and is reluctant to join the big game. Yet, he is finally seduced by the challenge as well as by the expectations of winning big, and moreover, he falls for the beautiful woman in this daring team that acts like the equivalent of a brainy Ocean's Eleven. Again games and women represent the classical elements and traditional topoi for vices. At the South Street diner (once known as the Blue Diner) – Boston's only restaurant open all night – Ben learns, while ¢Home¢ by Great Northern can be heard playing in the background, that the team's counting cards strategy includes some strict role-playing, since Professor Rosa's line-up has to split into two kinds of players: the 'spotters¢, who constantly play the minimum bet, keeping track of the count, sending secret signals and giving code words; and the 'big players¢, who place large bets whenever the count at a table is favourable. The rules in this scene open yet another timeless old play: reason against emotion, virtues versus vices. And Boston, the Athens of America, is again here presented in contrast with the notorious Vegas Strip. **⇥Pamela C. Scorzin**

Directed by Robert Luketic
Scene description: Spotters and Big Players
Timecode for scene: 0:30:03 – 0:32:03

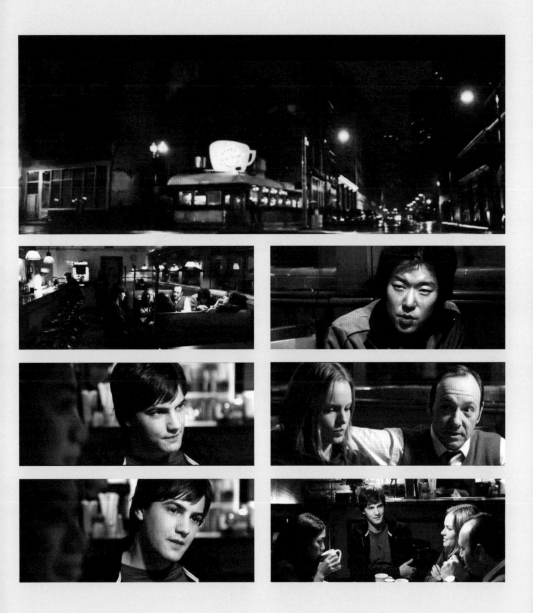

MY BEST FRIEND'S GIRL (2008)

Old South Church, 645 Boylston Street

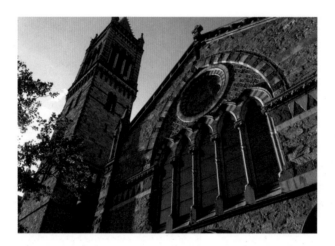

TANK (DANE COOK) gets hired by neglectful boyfriends to take their ex-girlfriends out on dates. Tank's modus operandi is to show these girls a terrible time so they appreciate and take back their former boyfriends. This requires only a slight alteration of Tank's normal personality and behaviour until he meets Alexis (Kate Hudson), whom Tank is hired by his best friend Dustin (Jason Biggs) to string along and mistreat. Alexis asks Tank to accompany her to her sister's wedding at the majestic Old South Church in Boston. The opening scene of the wedding sequence begins with a crane-shot that starts at the level of the exterior stained glass windows and glides down to ground level to find Alexis emerge from the church in a striking red dress. Alexis moves away from the church's entrance only to encounter Tank, dressed in an all-black tuxedo. The two embrace warmly in front of the church and Tank declares that he 'would like to do' Alexis right there. The browns of the church's exterior walls provide a neutral backdrop for the passionate Alexis, dressed in red, and the duplicitous Tank, clothed completely in black. Alexis then introduces Tank to Josh, whom Tank actually already knows because he 'tanked' his date with Josh's bride in the first sequence of the film. Josh reminds Tank to proceed with the plan of treating Alexis badly so that Dustin can swoop in and rescue her. Colour and setting are essential components to this pivotal scene. ➥**Lance Lubelski**

Photo © Edward Eaton

Directed by Howard Deutch
Scene description: Tank and Alexis meet before the wedding of Alexis's sister
Timecode for scene: 1:11:21 – 1:13:17

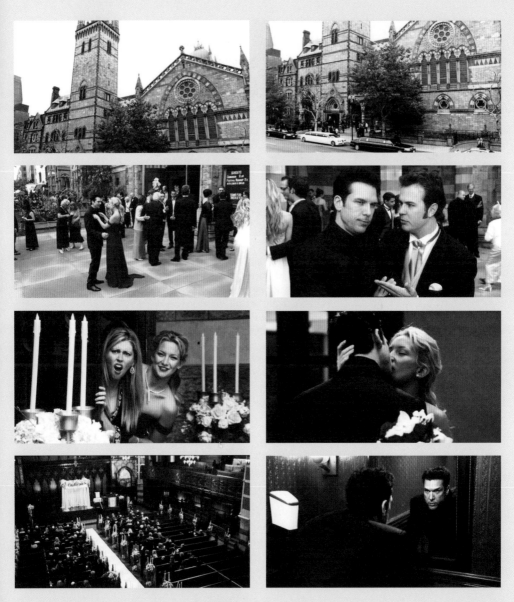

THE BOX (2009)

Boston Public Library, 700 Boylston Street

'WHAT WOULD YOU DO?' is the question the movie raises. A stranger drops a box at the Lewis family's doorstep. It is accompanied by an offer: push its button, and the couple will receive one million dollars, but a person unknown to them will die ... Wife Norma pushes the button, setting the story into action. Eventually, the couple find themselves at the Boston Public Library, used for its real-life purpose: research. Most intriguing in the sequence is the cinematography and usage of both Library buildings, Johnson and McKim, beginning and ending at the modern Johnson Building. Steadicam point-of-view shots and cinematography that centre most subjects and objects enhance the architectural symmetry of rooms and the sterile, dreary look the building transmits, with grey walls, bookcases and stairs. The camera work permits architectural features to overpower the characters, emphasizing the couple's helplessness. As husband Arthur crosses the centred path in the study room of the McKim Building – opened in 1895 – the symmetrical green desk lamps and readers rising from their chairs in unison create an eerie feeling. Arthur eventually arrives at the mural-filled Abbey Room in which the wall paintings 'The Quest and Achievement of the Holy Grail' were installed in 1895 by Edwin Austin Abbey. They function as an analogy of the couple's dilemma. The Holy Grail was the Last Supper's sacred vessel, and later collected the Lord's blood. Arthur, centred in the room and surrounded by the paintings, is trying to choose the only gateway – his own sacred vessel – that will bring him and his family 'salvation' from 'eternal damnation'. The library rooms look the same today as they do in the movie – this part of the film demonstrates effective usage of location shooting put simply and centred on the point. **↦Monika Raesch**

Photo © Edward Eaton

Directed by Richard Kelly
Scene description: Investigation in the Library
Timecode for scene: 1:06:06 – 1:15:57

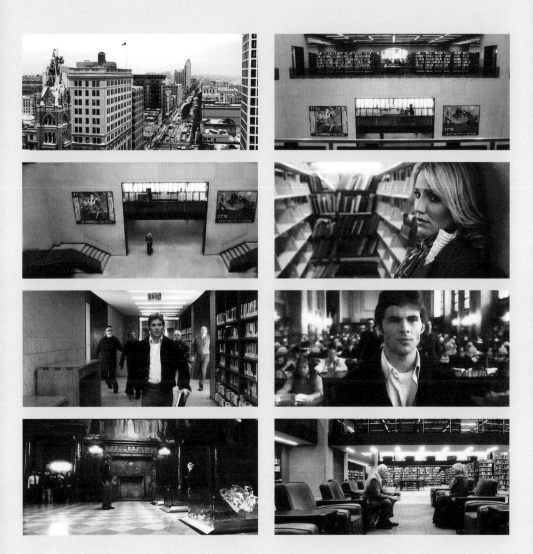

Images © 2009 Warner Bros.

VERITAS AND THE CRIMSON SCREEN

Harvard in Film

Text by
MARCELLINE
BLOCK

ESTABLISHED IN 1636, Harvard, oldest institution of higher learning in the US, is located in Cambridge, Mass., separated from Boston by the Charles River (Harvard Medical School, however, is located in Boston). One of the most prestigious Ivy League universities, Harvard boasts eight US Presidents among its alumni, along with innumerable luminaries in all fields.

Harvard affiliates in the seventh art form an impressive roster of household names: actors, directors, screenwriters, studio executives, talent managers. Along with famous faculty members including Stanley Cavell, Tom Conley, Alfred Guzzetti and Ross McElwee, Harvard's resources for film study/production include the Harvard Film Archive, one of the US's largest university collections, housed in the Carpenter Center for the Visual Arts – a building designed by Le Corbusier. Harvard's Film Study Center bestows fellowships for innovative audiovisual productions. The Hasty Pudding Theatricals ('The Pudding') names two entertainers its Man and Woman of the Year. Honorees – Lucille Ball, Sandra Bullock, Marion Cotillard, Whoopi Goldberg, Samuel L. Jackson, Martin Scorsese, Steven Spielberg, Meryl Streep, among others – are celebrated in an on-campus ceremony. In October 2013, Steven Spielberg was one of six recipients- along with Supreme Court Justice Sonia Sotomayor- of the W.E.B. Du Bois medal, Harvard's highest honor in African and African-American studies. Harvardwood, a non-profit organization for Harvard affiliates in arts and entertainment, was founded in 1999.

Harvard's campus, with red brick neo-Georgian buildings, shines in the collective unconscious, exuding power, prestige, and privilege – in other words, *The Harvard Mystique*, to cite the title of Enrique Hank Lopez's 1979 book.

Films portraying Harvard include James Bridges' *The Paper Chase* (1973; adapted from Harvard college/law school alum John Jay Osborn, Jr.'s novel); *A Small Circle of Friends* (1980, dir. by Harvard grad Rob Cohen); 1994's *With Honors* (dir. by Harvard alum Alek Keshishian); *Harvard Man* (2001; dir. by James Toback, Harvard '66); 2001's *Prozac Nation* (based on Harvard alum Susanna Kaysen's memoir) and *How High* (dir. Jesse Dylan). Directed by Harvard alum Kevin Rafferty, *Harvard Beats Yale 29-29* (2008) documents 'the most famous football game in Ivy League history,' the 1968 match between America's oldest college football rivals. In 2013, Harvard triumphed over Yale at their 130th football showdown known as 'The Game' – the Crimson's seventh victory in a row. Discussed herewith are several iconic Harvard films:

John Wayne made his film debut as a Yalie football player in the silent 1926 *Brown of Harvard* (dir. Jack Conway), filmed on location in Cambridge. *Mystery Street/Murder at Harvard* (John Sturges, 1950), an early police procedural 'in which Boston got its first taste of big-screen glory' (Sherman, p. iii), features Harvard Medical School's Legal Medicine Department (phased out later, in 1966).

Filmed in Harvard Yard, Arthur Hiller's melodrama *Love Story* (1970) immortalized Harvard onscreen, featuring alum Tommy Lee Jones in his first film role (as a roommate of the protagonist). *Love Story* was written by Erich Segal, a Yale classics professor who obtained his BA, MA, and PhD at Harvard. *Love Story* narrates the tragic amorous relationship between privileged Harvard undergraduate Oliver (Ryan O'Neal) and Radcliffe scholarship student Jennifer (Ali MacGraw). Along with showcasing campus locations, *Love Story* portrays Harvard life and opens the door to audiences eager to penetrate this bastion of elitism and intellectual culture, inaccessible but greatly desired by the uninvited. *Love Story* became an annual ritual for Harvard undergraduates who, during Freshman Week, attend a screening held by the Crimson Key Society whose members heckle the entire film,

Above © 1994 Warner Bros./Spring Creek Productions

Skyler (Minnie Driver) who is a Harvardite from a privileged background, while her love interest, autodidact/genius Will Hunting (Damon), is a blue collar worker at MIT. Harvard Square locations include the exterior of the shuttered Bow and Arrow Pub; the Au Bon Pain café across Harvard Yard; the Tasty, a fondly remembered eatery/Harvard Square institution that closed the year *Good Will Hunting* was released. For Affleck, the film highlights the 'contrast between university life' and that of Cambridge residents (Sherman, p. ix). *Good Will Hunting*, a personal odyssey for Damon and Affleck, won the Best Original Screenplay Oscar; Damon partially wrote the film while still an undergraduate at Harvard before leaving college for Hollywood. During a sequence at Au Bon Pain, friends and relatives of Damon and Affleck, including Damon's father, were recruited as extras. There is a mix and match of authentic and borrowed locations. For budgetary concerns, many interior scenes were filmed in Toronto, such as the Bow and Arrow Pub sequence – when Will outsmarts an arrogant Harvard student – as well as Skyler's dormitory room. Yet there is an authentic exterior shot of her residence, Harvard's Dunster House.

Unlike the Harvard interiors in *Good Will Hunting*, in *The Great Debaters* (Denzel Washington, 2007) the championship debate between Harvard and historically black university Wiley College – which actually took place between Wiley and USC in 1935 – was filmed inside Sanders Theatre. Sanders, located in Harvard's Memorial Hall, is an amphitheater for performances and Harvard lecture courses, such as core curriculum classes 'Justice' and 'First Nights.'

Harvard's impact on filmmaking shows no sign of slowing down: forthcoming documentary *Left on Pearl: Women Take Over 888 Memorial Drive, Cambridge* (dir. Susan Rivo) revisits the 1971 feminist occupation of a Harvard building, which subsequently became the Cambridge Women's Center, longest operating women's center in the US. For Harvard history professor Nancy Cott, *Left on Pearl* 'is the best thing I've seen on second wave feminism.'

Since 2006, Harvard's Sensory Ethnography Lab, directed by Lucien Castaing-Taylor, has produced 'some of the most daring and significant documentaries of recent years' (Dennis Lim, *New York Times*).

Harvard's significant impact upon the seventh art – through its faculty, alumni, students, and research/ study centers – is reflected by its impressive cinematic presence, achievements and production.✠

not sparing its iconic line 'love means never having to say you're sorry' (ironically resemantized in the television show *Weeds* as '*thug* means never having to say you're sorry').

Post-*Love Story*, Harvard requires permission to film on campus. Commercial filming is not permitted, nor are tripods allowed in Harvard Yard, the university's original grounds, lined by freshman dormitories along with Harvard's oldest structure, Massachusetts Hall – home to its president's office – as well as other iconic sites: Widener Library, Memorial Church, the John Harvard Statue. Thus, filmmakers turn to onscreen surrogates: in *The Social Network* (David Fincher, 2010), about the creation of Facebook by several Harvardians, campus scenes were filmed at Johns Hopkins University (Baltimore), Boston's Wheelock College and Milton Academy; *Legally Blonde* (Robert Luketic, 2001), set at Harvard Law School, filmed in California locations including USC, yet aerial shots of Harvard portray the picture-perfect towers of undergraduate residences Eliot and Lowell House; in *Angels and Demons* (Ron Howard, 2009), UCLA's Royce Hall serves as Harvard's stand-in.

Good Will Hunting (Gus Van Sant, 1997), penned by Cantabrigians Matt Damon and Ben Affleck – distant cousins and lifelong friends – somewhat reverses the gender/class dynamics of *Love Story*: in *Good Will Hunting*, it is the female character,

Harvard's campus, with red brick neo-Georgian buildings, shines in the collective unconscious/popular imagination, exuding power, prestige, and privilege.

N

LOCATIONS MAP

BOSTON

maps are only to be taken as approximates

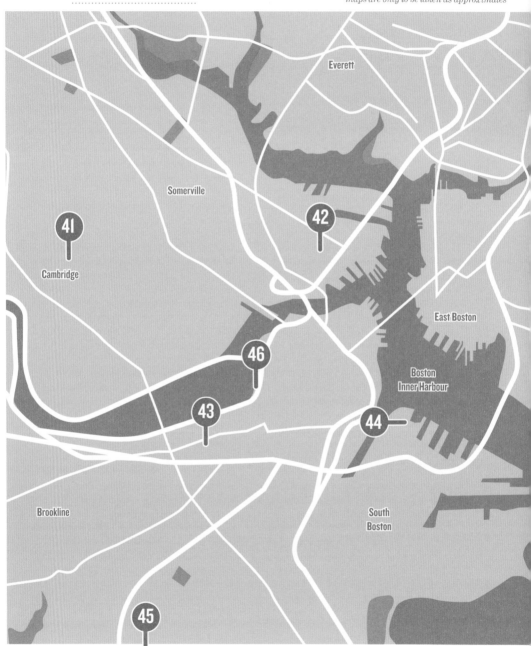

Everett

Somerville

42

41

Cambridge

East Boston

46

Boston
Inner Harbour

43

44

Brookline

South
Boston

45

BOSTON LOCATIONS
SCENES 40-46

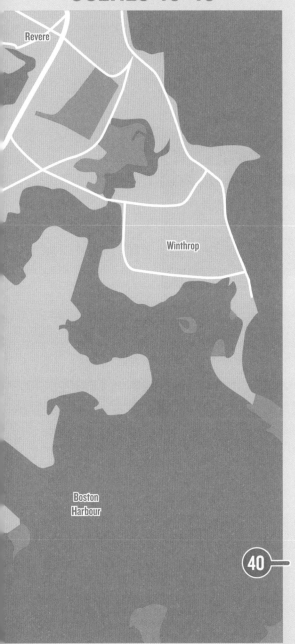

Revere

Winthrop

Boston
Harbour

40

40.
SHUTTER ISLAND (2010)
Peddocks Island, Boston Harbor
page 110

41.
THE SOCIAL NETWORK (2010)
The Thirsty Scholar Pub, 70 Beacon Street,
Somerville
page 112

42.
THE TOWN (2010)
Bunker Hill Monument, Monument Square,
Charlestown
page 114

43.
THE COMPANY MEN (2010)
Daisy Buchanan's Bar, 240 Newbury Street
page 116

44.
WHAT'S YOUR NUMBER? (2011)
The Institute of Contemporary Art,
100 Northern Ave.
page 118

45.
ZOOKEEPER (2011)
Franklin Park Zoo, 1 Franklin Park Road
page 120

46.
TED (2012)
Boston Hatch Shell, 47 David G. Mugar Way
page 122

SHUTTER ISLAND (2010)

LOCATION *Peddocks Island, Boston Harbor*

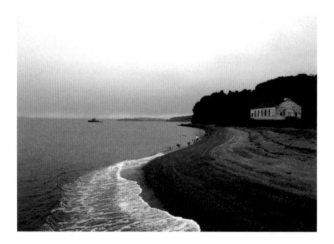

IN SHUTTER ISLAND, Martin Scorsese blends genres with ease, shifting from suspense thriller to crime film to disturbing ghost story. The title is part of that mystery, deconstructing into an anagram for 'Truths and Lies' or 'Truths/ Denials'. Take your pick. The film opens with ominous notes, both on the unsettling soundtrack and through washed out visuals. US Marshall Teddy Daniels (Leonardo DiCaprio), a World War II veteran, and his new partner Chuck Aule (Mark Ruffalo) arrive at the fog-shrouded Shutter Island, home to a federal hospital for the criminally insane. Their assignment is to find an escaped mental patient. The atoll looks like a foreboding rock, rising from murky waters; its dock guarded by hard faced men who cover the island's riddles wrapped in mysteries that hide enigmas (to paraphrase Churchill). From there, Scorsese draws the viewer into a self-contained world where perception and reality are fluid, as Daniels encounters psychological demons from his military and personal past, and eerie spectres that seem to haunt the island itself. In reality, Scorsese's nightmare realm is Boston's historic Peddocks Island, a modern nature preserve that is part of the Boston Harbor Island National Recreation Area. Once home to pre-colonial Native Americans, from the late nineteenth century to the end of World War II Peddocks Island was the site of Fort Andrews, a military base that protected the city from possible invasions. The fort was decommissioned in 1946, falling into disrepair until Commonwealth of Massachusetts acquired the property in the 1970s. Some buildings from the old structure were used in the film. Many have since been torn down, making way for beautiful hiking trails and historic tour trips. ↝*Arnie Bernstein*

Photo © Monika Raesch

Directed by Martin Scorsese
Scene description: Welcome to Shutter Island
Timecode for scene: 0:00:33 – 0:05:51

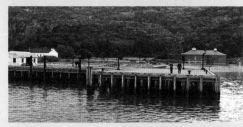
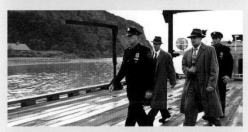

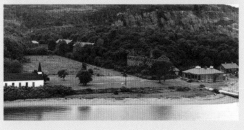

THE SOCIAL NETWORK (2010)

LOCATION *The Thirsty Scholar Pub, 70 Beacon Street, Somerville*

THE SOCIAL NETWORK is about communication. The film's agenda is laid clear in the opening scene, in which Erica Albright dumps her boyfriend, the film's protagonist, Mark Zuckerberg. For a film concerned with the revolutionary effects on communication pioneered by Zuckerberg it is appropriate that the film portraying a fictionalized take on his life opens with a scene purely ground in the methods of the old. As such, the Thirsty Scholar scene is a timeless moment in a film that nary pauses for breath for the remainder of its 121-minute running time. The rapid-fire, theoretically identity-less dialogue, which segues from idle gossip to heartfelt declaration of hopelessness, stands as the ideological opposite of the permanent, digitalized strain of dialogue that social media like Facebook would come to represent. The edit reflects the tone of the dialogue. Fast cuts remove a particular character from within the frame before they've finished speaking. As a technical exercise the scene is a marvel, with Fincher drawing from 99 takes to put the sequence together. An impressive 114 shots fill a running time of just five minutes and six seconds, while only five camera set-ups are used. The use of the track 'Ball & Biscuit' (2002) by The White Stripes to score the sequence is further evidence of Fincher's meticulous attention to detail. What may appear to be little more than background noise provides several layers worth of information and subtext to the scene. The organic, pre-digital song was recorded on antiquated, pre-1960s recording equipment, including an eight-track tape machine. This resonates with the fact that this scene marks the only semblance of an 'old world' within *The Social Network*. Every other scene takes place within the post-Facebook age.
•➤Adam Batty

Photo © Ken Martin / Amstockphoto.com

Directed by David Fincher
Scene description: Mark is dumped by his girlfriend
Timecode for scene: 0:00:24 – 0:05:08

Images © 2010 Columbia Pictures/Relativity Media/Scott Rudin Productions

THE TOWN (2010)

LOCATION *Bunker Hill Monument, Monument Square, Charlestown*

A MUCH-LAUDED second directing effort by Boston native Ben Affleck, *The Town* focuses on Charlestown, a blue-collar neighbourhood of Boston. According to *The Town*, being from Charlestown is a dark birthright: the neighbourhood has produced the most bank robbers and car thieves, and being from Charleston can ruin your life. Affleck stars as Doug MacRay, a strangely sensitive and compassionate bank robber who wants out of the life of crime in the film adaptation of Chuck Hogan's novel *Prince of Thieves* (2004). The first image of the film is the Bunker Hill Monument, located in Monument Square in Charlestown. The Monument memorializes the Battle of Bunker Hill, the first engagement between the British and American armies in the Revolutionary War on 17 June 1775. Before the current obelisk, a wooden monument was erected on the site in 1794 to honour Dr Joseph Warren, a Revolutionary hero and patriot killed during that battle, also the President of the Massachusetts Provincial Congress who sent Paul Revere on his midnight ride to warn Concord that 'the British were coming'. A looming presence throughout the film, the Bunker Hill Monument provides a sense of neighbourhood and place, but also a reminder of the legacy of violence that Doug and his crew can't quite escape. In this scene, Doug opens up to Claire (Rebecca Hall) about his mother in the Charlestown Community garden. The Bunker Hill Monument starts the scene, but then disappears as they begin to talk, leaving only flowers. ⤙*Kristiina Hackel*

Photos © Monika Raesch

Directed by Ben Affleck
Scene description: Doug and Claire exchange confidences in the Charleston Community Garden
Timecode for scene: 0:31:45 – 0:34:55

THE COMPANY MEN (2010)

LOCATION *Daisy Buchanan's Bar, 240 Newbury Street*

'**IN AMERICA,** we give our lives to our jobs. It's time to take them back.' This is the film's main credo, and obviously no other form of rebellion or protest can be imagined in today's hub of the universe, following the financial crisis of 2008 and the recession. When corporate downsizing leaves even white-collar workers and other highly paid executives of a transportation conglomerate suddenly jobless, these characters are forced to re-define their lives as men, husbands and fathers. The global financial crisis becomes individualized and personalized. As many American employees have to leave their workplaces in modern high-rise buildings made of glass, steel and concrete, each of them has to find a way to adjust their lifestyles in a dramatically changing world to adapt to the new situation, a completely different setting. While Bobby Walker (Ben Affleck) accepts a temporary manual labour job, offered by his blue-collar brother-in-law, his elder colleague Phil Woodward (Chris Cooper) feels ashamed about being laid off and hides away by drowning his sorrows in Daisy Buchanan's, a cozy bar at the corner of Newbury and Fairfield Street. This Back Bay institution, first opened in September 1970, holds its reputation as one of the more popular places located on Boston's most enchanting and expensive street, a mile-long stretch lined with traditional nineteenth-century brownstones and eight blocks filled with dining establishments and exclusive retail stores. However, Gene McClary (Tommy Lee Jones) and ex-senior manager Woodward sit in the basement of this historical district and modern consumers' paradise, having a depressing conversation about the internal and external effects of being jobless in tough economic times.
✷ Pamela C. Scorzin

Photo © Edward Eaton

Directed by John Wells
Scene description: Bar conversation about being laid off and jobless
Timecode for scene: 1:10:10 – 1:11:41

 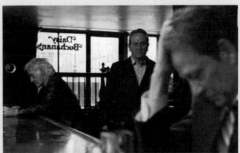

WHAT'S YOUR NUMBER? (2011)

The Institute of Contemporary Art, 100 Northern Ave.

WHAT'S YOUR NUMBER? follows Ally Darling (Anna Faris) after she is fired from her job and has an epiphany: she has already had sex with nineteen men. She soon makes a drunken vow not to exceed twenty lovers, or else she might never meet 'The One' – the man whom she will marry. That night, however, she beds her twentieth lover (Joel McHale), and is apoplectic the next morning when her neighbour Colin (Chris Evans) saves her from having to interact any further with that man (incidentally, the boss who fired her). Ally and Colin then make an agreement that he will track down her ex-lovers so that she can find her husband among those twenty guys. In exchange, she will let him hide from his one-night stands in her apartment. The audience knows from their first scene together that Ally and Colin will end up a couple, but the two leads require some convincing. Ally meets up with her former lovers, the most promising being her high school sweetheart Jake Adams (Dave Annable), from a socially prominent family. Jake takes Ally to a black-tie function at Boston's Institute of Contemporary Art, a massive modern glass structure sitting on Boston Harbor. The two stare out at the Harbor as the sun sets, but the coldness of the glass surrounding them mirrors their lack of a romantic connection. Ally's awkward behaviour inside the museum only reaffirms the viewer's earlier impressions that Jake is wrong for her. Conversely, Ally's scenes with Colin around Boston take place in more historic neighbourhoods, suggesting warmth and comfort. Here, the cinematic use of Boston reinforces distance between some characters and growing bonds between others. ⟶*Lance Lubelski*

Directed by Mark Mylod
Scene description: Ally accompanies Jake Adams to an event
Timecode for scene: 1:19:30 – 1:19:57

Images © 2011 20th Century Fox/Regency Enterprises/Contrafilm

ZOOKEEPER (2011)

Franklin Park Zoo, 1 Franklin Park Road

KEVIN JAMES PLAYS Griffin, the likeable but hapless chief zookeeper at the Franklin Park Zoo. In the opening scene, he rides on horseback along the beach with his girlfriend Stephanie. He asks her to marry him but she rejects him. Five years later, he has not yet recovered from this heartbreak but loves working as a zookeeper. The sentient animals of the zoo know all about his woes because he confides in them as he feeds them and washes out their enclosures. One night, after the zoo has closed for the day, the animals hatch a plan to help Griffin get Stephanie back by making Griffin look like a hero. In their first attempt to make Griffin look like a hero in front of Stephanie, the animals free a lion which is supposed to scare her until Griffin can save her. Griffin springs into action, leaping into an enclosure and smashing himself against the rocks. The lion, disgusted with Griffin, exclaims, 'What the hell are you doing?' Griffin is understandably shocked at the lion's powers of speech and runs off, only to be confronted by the talking monkey and the talking giraffe as he dashes from the Zoo through the magisterial front gates, gates flanked on either side by huge marble elephants. The animals' further efforts to valorize their beloved zookeeper at the CGI-enhanced Franklin Park Zoo will only make it obvious to everyone (Griffin, the animals, the viewer) that Griffin belongs with another woman who shares his interests.

⟿Lance Lubelski

Photo © Ken Martin / Amstockphoto.com

Directed by Frank Coraci
Scene description: *Griffin learns that the zoo animals can talk*
Timecode for scene:0:18:54 – 0:21:46

Images © 2011 Columbia/MGM/Broken Road/Happy Madison

TED (2012)

LOCATION *Boston Hatch Shell, 47 David G. Mugar Way*

TED, THE DIRECTORIAL DEBUT of television cartoon king Seth MacFarlane (*Family Guy*; *American Dad*) is a buddy comedy of the most profane order. John (Mark Wahlberg) is a thirty-something adolescent living with his long-suffering girlfriend Lori (Mila Kunis). There is a third wheel in this love story, Ted (voiced by MacFarlane), John's teddy bear who magically came to life years ago thanks to a childhood wish. Ted may have been a charmer in his youth, but now he's a foul mouthed, dope smoking, has-been celebrity – though still John's best buddy. When their bromance becomes too much for Lori, she throws John out. A guilt-ridden Ted goes backstage at the Hatch Shell where his old lover, singer Norah Jones is performing (yes, this is the kind of movie where Norah Jones once had 'awkward fuzzy sex' with a genital-free teddy bear). Jones agrees to let John try to win back his true love by serenading Lori during the concert. Good intentions fall apart when John's excruciatingly out of tune rendition of 'All Time High' (the theme from *Octopussy* [John Glen, 1983]) sparks an audience riot. Part of the joke is that Wahlberg is well known for his previous career as a pop star. Despite her ex's melodically challenged crooning, Lori feels the love within. The Edward A. Hatch Memorial Shell (aka 'The Hatch Shell') is one of Boston's premiere music venues. Located on the banks of the Charles River near downtown Boston, the Shell is home to the annual Boston Pops Fourth of July concert instituted by legendary conductor Arthur Fielder. Throughout the summer this venue is home to rock and classical music concerts and free evening movies, and is a central gathering point for many public fundraising events. A beautiful setting indeed for lovers everywhere and their foul mouthed, dope-smoking teddy bears. **⇢ Arnie Bernstein**

Directed by Seth MacFarlane
Scene description: Norah Jones concert
Timecode for scene: 1:10:10 – 1:12:11

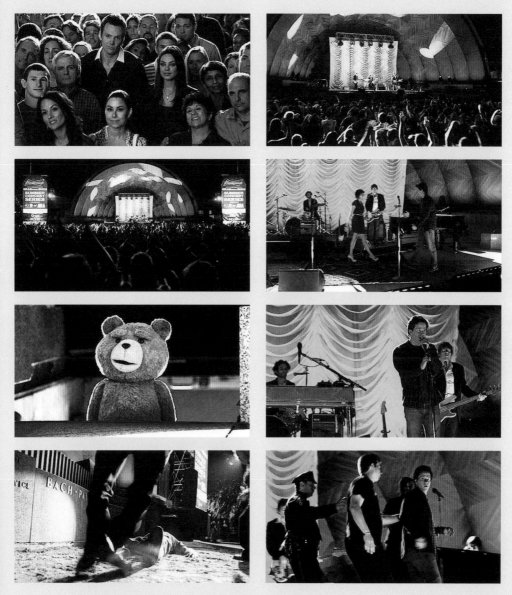

Images © 2012 Universal Pictures/Media Rights Capital/Fuzzy Door Productions

GO FURTHER

Recommended reading, useful websites and film availability

BOOKS

Big Screen Boston: From *Mystery Street* to *The Departed* and Beyond
by Paul Sherman
(Black Bars Publishing, 2008)

Boston's Downtown Movie Palaces
(Images of America series)
by Arthur Singer and Ron Goodman
(Arcadia Publishing, 2011)

Bringing Down the House: The Inside Story of Six MIT Students Who Took Vegas for Millions
by Ben Mezrich
(Free Press, 2003)

The Harvard Mystique: the Power Syndrome That Affects Our Lives from Sesame Street to the White House
by Enrique Hank Lopez
(Macmillan, 1979)

Love Story
by Erich Segal
(Harper & Row, 1970)

The Poetical Works of Henry Wadsworth Longfellow
('The Bridge', p. 85)
by Henry Wadsworth Longfellow
(Houghton, Mifflin & Co., 1885)

Prince of Thieves: A Novel
by Chuck Hogan
(Scribner, 2004)

ARTICLES/MAGAZINES

'Redemption Hunting'
by Charles McGrath
The New York Times, 14 October 2007

'Erich Segal, Love Story Author, Dies at 72'
by Margalit Fox. *New York Times*, 19 January 2012

'The Merger of Academia and Art House: Harvard Filmmakers' Messy World'
by Dennis Lim. *The New York Times*, 31 August 2012

'First Printed Book in America Expected to Fetch Up to $30M in Auction'
by Erica Ho. *Time.com*, 21 April 2013

FILMS

Collier Strong
narrated by Donnie Wahlberg
(NASCAR/Fox Sports 1, 2013)

Left on Pearl: Women Take Over 888 Memorial Drive, Cambridge
directed by Susan Rivo, edited by Iftach Shavit
(The 888 Women's History Project, forthcoming)

ONLINE

Film Adaptions of Dennis Lehane's novels
http://www.dennislehane.com/filmtv
Loaded Gun Boston (Boston filming sites)
http://www.loadedgunboston.com/
Big Screen Boston
http://www.bigscreenboston.com/
Massachusetts Film Office
http://www.mafilm.org/
Boston Society of Film Critics
http://www.bostonfilmcritics.org/
Film Study Center at Harvard University
http://www.filmstudycenter.org/about.html
Harvard Film Archive
http://hcl.harvard.edu/hfa/general_info.html
'Boston in the Movies: A Short Guide to Beantown Blockbusters'
by Colton Welch (*Let's Go*, 2 April 2013)
http://www.letsgo.com/north-america/blogs/
'History of the Station'
South Station: Boston's Great Room (n.d.)
http://www.south-station.net/Station-History.htm

CONTRIBUTORS

Editor and contributing writer biographies

EDITOR

MARCELLINE BLOCK teaches and writes about art, cinema and literature. Her publications include *World Film Locations: Prague* (Intellect, 2013); *World Film Locations: Marseilles* (Intellect, 2013), translated into French as *Filmer Marseille* (Presses Universitaires de Provence, 2013); *World Film Locations: Las Vegas* (Intellect, 2012); *World Film Locations: Paris* (Intellect, 2011); and *Situating the Feminist Gaze and Spectatorship in Postwar Cinema* (Cambridge Scholars, 2008; 2nd ed., 2010), named Book of the Month for the Arts in January 2012 by its publisher, and translated into Italian as *Sguardo e pubblico femminista nel cinema del dopoguerra* (Aracne editrice, 2012). She co-edited *Unequal Before Death* (Cambridge Scholars, 2012; with a grant from Columbia University), named Book of the Month for the Social Sciences, September 2012; *Gender Scripts in Medicine and Narrative* (Cambridge Scholars, 2010); and 'Collaboration', a special issue of *Critical Matrix: The Princeton Journal of Women, Gender, and Culture* (vol. 18, 2009). She has contributed chapters to numerous edited volumes. Her articles appeared in the journals *Excavatio*, Vol. XXII: *Realism and Naturalism in Film Studies* (2007); *The Harvard French Review* (2007); *Women in French Studies* (2009, 2010); and *Afterall* (2012), among others. Her writing has been translated and published in Chinese, French, Italian, Korean and Russian. Educated at Harvard (BA) and Princeton (MA, PhD cand.), at Princeton Marcelline has taught French, English, and comparative literature as well as History as a Lecturer. Among her lectures, presentations and conferences, she spoke about Paris in film at 92YTriBeCa in New York City.

CONTRIBUTORS

ADAM BATTY is a writer and lecturer on film based in the United Kingdom. He is the founding editor of *Hope Lies at 24 Frames Per Second* and Editor-In-Chief of *Periodical*. His core interests lie in French cinema, having completed his MA thesis on the role of gender in the works of Jean-Luc Godard, and with the effects of the digital revolution on film culture.

ARNIE BERNSTEIN is author of *Swastika Nation: Fritz Kuhn and the Rise and Fall of the German-American Bund* (St. Martin's Press, 2013), a book that garnered his writing comparison to Quentin Tarantino's film-making in a *Publishers Weekly* review. Arnie's film scholarship includes *Hollywood on Lake Michigan: 100+ Years of Chicago and the Movies* (Chicago Review Press, 2013) and a study of poet Carl Sandburg's film criticism of the 1920s, '*The Movies Are*': *Carl Sandburg's Film Reviews & Essays 1920–1927* (Lake Claremont Press, 2000). The late Roger Ebert contributed a thoughtful introduction to

this latter volume. *Bath Massacre: America's First School Bombing* (University of Michigan Press, 2009), his true-crime account of a 1927 school mass murder, was named a Notable Book of the Year by the State Library of Michigan. Arnie lives in Chicago where he earned his Master's degree at Columbia College, teaches college writing, and doesn't need The Book of Job as he is a White Sox fan. Catch him on the Internet at www.arniebernstein.com.

HENRI-SIMON BLANC-HOÀNG holds a PhD (2005) in Latin American Literature from the University of Florida. Since 2007, he has taught Spanish, French, Latin American literature and Afro-Francophone Studies at the Defense Language Institute in Monterey and Seaside, California. Blanc-Hoàng's research interests include film studies, postcolonial/national and globalization studies, and graphic novels and science fiction studies. In addition to being a regular contributor to the World Film Locations book series, his article on nationalism in French graphic novels has appeared in the *Comics as History, Comics as Literature* anthology (Rowman & Littlefield, 2013). For 2014, Blanc-Hoàng's chapter on masculinity in twenty-first century Spanish cinema will be published in a collection of essays on Spain's contemporary cultural production. Blanc-Hoàng is now working on a new article about the pilgrimage to Santiago de Compostela in European and Ibero-American graphic novels.

OANA CHIVOIU is finishing her dissertation in Theory and Cultural Studies at Purdue University and has special interests in issues of migration, displacement and post-communism in European cinema. Her publications about cinema, cultural studies and post-communism have appeared in *Short Film Studies*, *Film International*, the World Film Locations series (Paris, Las Vegas and Marseille volumes), *Many Cinemas* and will appear in the Directory of World Cinema series (Belgium and Scotland volumes). Her research work in Victorian studies was presented at numerous conferences and is the focus of her dissertation. Her latest publication is the article 'Childless Motherhood: The Geopolitics of Maternal Bliss in Fatih Akin's *The Edge of Heaven*' published in the collection of essays *Disjointed Perspectives on Motherhood* (Lexington Books, 2013) edited by Catalina Florescu.

EDWARD EATON is the award-winning poet and author of the Rosi's Doors series and the plays *Elizabeth Bathory* (Dragonfly Publishing, 2012), *Orpheus and Eurydice* (Dragonfly Publishing, 2013) and *Hector and Achilles* (Dragonfly Publishing, 2013). He was also a contributor for the Prague edition of World Film Locations. Dr Eaton holds a PhD in Theatre History and Literature from Bowling Green State University and has taught at an astonishing number of universities and colleges in the ➜

CONTRIBUTORS

Editor and contributing writer biographies (continued)

States and overseas. Currently, he lives in Boston with his wife and son and works as a theatrical director and fight choreographer and as a writer.

KRISTIINA HACKEL MFA, PhD, is Associate Professor in the Department of Television, Film, and Media Studies at California State University, Los Angeles. She also currently serves as the Director of the MFA Program in Television, Film and Theatre and Associate Chair of the Department of Television, Film, and Media Studies. Her publications include recent contributions to *World Film Locations: Marseilles* (Intellect, 2013), *World Film Locations: Prague* (Intellect, 2013) and the forthcoming *Women Screenwriters: An International Guide* (Palgrave Macmillan, 2013). An award-winning film-maker, her last directing project, *Speedie Date*, was nominated for a 2009 Webby Award.

ANDREW HOWE is Associate Professor of History at La Sierra University, where he teaches courses in film history and theory, popular culture, and American history. Recent publications include articles on the evolution of the hot dog as a bellwether of late-nineteenth-century immigration, and race and racism in *Star Wars*. Current research projects involve the rhetoric of fear employed during the recent invasion of the Everglades by Burmese Pythons, as well as the debate over the rediscovery of the Ivory-billed Woodpecker in Arkansas. These two works are conceived of as chapters in a book-length project exploring the manner in which societies translate environmental events by employing the familiar rhetorical strategies and vocabularies of existing, sociological problems.

ZACHARY INGLE is a PhD candidate in Film and Media Studies at the University of Kansas where he is completing a dissertation exploring Robert Rodriguez. He has written for several volumes in the World Film Locations series, including Las Vegas, Marseilles, Paris, Prague and Shanghai. Other work appearing in books by Intellect include Directory of World Cinema volumes devoted to Sweden, Belgium, Australia and New Zealand (Vol. 2), Japan (Vol. 3) and American Independent (Vol. 3), as well as *Fan Phenomena: Star Wars* (Intellect, 2013) and *Fan Phenomena: Marilyn Monroe* (Intellect, 2014). Ingle has edited three books: *Robert Rodriguez: Interviews* (University Press of Mississippi, 2012), *Gender and Genre in Sports Documentaries* (co-ed., Scarecrow Press, 2012) and *Identity and Myth in Sports Documentaries* (co-ed., Scarecrow Press, 2012). A fourth, Intellect's *Fan Phenomena: The Big Lebowski*, is forthcoming in 2014. His work has also appeared in journals such as *Literature/Film Quarterly*, *Journal of Sport History*, *Film & History*, *Journal of American Culture*, *Mass Communication and Society*, *Film-Philosophy* and *Journal of Religion and Film*.

KAREN LADANY is a professional photographer from northern Connecticut. She attended Suffolk University in Boston, and graduated in 2013 with a degree in film studies. Karen works as a visual marketing/media consultant and is the owner of Debut Cinematic, a Boston-based photography/videography company.

LANCE LUBELSKI is a PhD candidate in the Department of History at the University of Illinois at Urbana-Champaign. He is currently writing his dissertation on discourses of medical care in south-western Germany between 1450 and 1650. He holds a Master's in history from the University of Cincinnati, where he studied early-modern and modern Europe, and a BA from Kent State University, where he studied history and literature. He has presented at national conferences on blood and on the body. He has published work on Robert Bresson and on Julia Leigh's film *Sleeping Beauty*. He has previously contributed pieces to the World Film Locations volumes on Paris, Las Vegas and Marseilles. He has additionally written on Protestant wonder books in sixteenth-century Germany as well as on the sixteenth-century Spanish humanist Michael Servetus. He thanks his wife Sarah and his cat Susan for their boundless support and love.

KENNETH MARTIN is a photographer and educator based in Boston specializing in editorial photography, photojournalism and fine art. He is celebrating teaching photography and photojournalism for 25 years at Suffolk University in Boston, primarily in the Communication and Journalism Department and with the Graphic Arts Program of the New England School of Art and Design at Suffolk University. In addition to his Boston classes Kenneth has led study-abroad classes in his memorable 'Lens on …' photojournalism programme to the Suffolk University Campuses in Dakar, Madrid and the Lorenzo de Medici School Tuscania Campus in Italy. Kenneth has worked for many publications, businesses and organizations, has been widely exhibited, and received numerous awards including the Massachusetts Film Office Location Competition. Martin lives in Bolton, Massachusetts with his wife, artist Verjik Abramian, and son, Craig Martin, a new Suffolk University student studying Media Production. Kenneth's work may be seen at www.amstockphoto.com, www.facebook.com/kennethmartinphotography and www.kennethmartinphotography.zenfolio.com.

DAN AKIRA NISHIMURA wrote about several films for *World Film Locations: Prague* (Intellect, 2013). In 2012, he received an MA in Cinema Studies from San Francisco State University. He is a regular contributor to *Noir City* and the *Bright Lights Film Journal*. 'I lived through the 1970s and 80s and was amused to look back on that era. It was an exciting, colorful time and these movies set in Boston reflect that. I'd again like to thank Editor Marcelline Block for her patience and dedication.'

MONIKA RAESCH (PhD, European Graduate School) is Assistant Professor of Communication and Journalism at Suffolk University, Boston. She has published numerous articles on film analysis, including pieces in *The Journal of Film and Video* and *Visual Anthropology*. She is also the author of the monograph *The Kiarostami Brand: Creation of a Film Auteur* (LAP Lambert Academic Publishing, 2007). Her research on the usage of Boston and New England in films was presented at the 2013 Popular Culture Association/American Culture Association Conference in Washington DC. Besides teaching film history, theory and video-production classes, she teaches a course on film adaptation that includes the unit 'Boston in the Movies'. Her other main research area concerns teaching pedagogy. Work of hers can be found in *The National Teaching & Learning Forum* and *Innovative Higher Education*, among other publications.

ZACHARIAH RUSH is the author of *Beyond the Screenplay: A Dialectical Approach to Dramaturgy* (McFarland, 2012) – a Hegelian analysis of dramatic structures from Sophocles to Orson Welles. He is a contributing critic to seven volumes of the Directory of World Cinema series published by Intellect and has also contributed to the Paris, Marseilles, Las Vegas and Prague volumes of the World Film Locations series also published by Intellect. Zachariah is currently writing *Cinema and its Discontents* (forthcoming in 2014).

PAMELA C. SCORZIN is an art, design and media theorist and Professor of Art History and Visual Culture Studies at Dortmund University of Applied Sciences and Arts, Department of Design. Born 1965 in Vicenza (Italy), she studied European Art History, Philosophy, English and American Literatures, and History in Stuttgart and Heidelberg (Germany), obtaining her MA in 1992 and her PhD in 1994. She was an assistant professor in the Department of Architecture at Darmstadt University of Technology from 1995 to 2000. After completing her habilitation in the history and theory of modern art there in 2001, she was a visiting professor in Art History, Media and Visual Culture Studies in Siegen, Stuttgart, and Frankfurt am Main. Since 2005, she is a member of the German section of AICA. Her current

areas of research include scenographic design, fashion film and contemporary global art. She has published on art-historical as well as cultural-historical topics from the seventeenth to the twenty-first century.

ILA TYAGI is a PhD candidate in American and Film Studies at Yale University. Her interests include cultural studies of capitalism and modernity, petroleum conglomerates, global labour diasporas, reconfigurations of the nation-state, and citizenship. She completed an MA in American Studies at Columbia University in 2013. Her Master's thesis focused on food's role in shaping gender ideologies via scenes of women eating in film. A chapter from her thesis won the *Southwest/Texas Popular and American Culture Association Annual Conference*'s Diana Cox Award for Images of Women. Ila also received Columbia's inaugural Pat Anderson Prize in Film Reviewing for her piece on the Chilean documentary *Nostalgia for the Light* (2010). She graduated with a BA in English Literature from Brown University in 2009. While at Brown, she programmed the world cinema division of the Ivy Film Festival. Additionally, Ila worked in corporate public relations between college and graduate school. She grew up in India and Kuwait.

KATHERINE A. WAGNER is a doctoral candidate in Humanities at the University of Louisville. Her film location and scene analyses can be found in *World Film Locations: Marseilles* (Intellect, 2013) and *World Film Locations: Prague* (Intellect, 2013), both edited by Marcelline Block. She is the co-author of a paper, accepted as part of an edited collection of essays, on the role of place within young adult fantasy dystopian novels. She is also the author of a forthcoming paper examining placelessness within Joss Whedon's film *The Cabin in the Woods*. In her dissertation work, Katherine is exploring the role of placelessness within American horror literature and film. Her other interdisciplinary research interests include issues of identity, place and the carnivalesque within fantasy and speculative fiction. Katherine is also a published author of fiction under the name Katherine A. W. Troyer. Her story 'Selling Happiness' can be found in the Winter 2012/13 issue of *Calliope*.

FILMOGRAPHY

All films mentioned or featured in this book

21 (2008)	9, 91, 100
Alex & Emma (2003)	48, 71, 84
All That Heaven Allows (1955)	7
Alma Mater (2002)	49
Altered States (1980)	18, 31, 40, 68, 69
Amélie (2001)	48
America (1924)	5, 6, 11, 12
American Dad (2005-present)	122
American Hustle (2013)	5
Amistad (1997)	51, 66
Angels and Demons (2009)	107
Annie Hall (1977)	48
Argo (2012)	29
The Babe (1992)	88
The Babe Ruth Story (1948)	88
Birth of a Nation (1915)	7
Blown Away (1994)	51, 60
The Boondock Saints (1999)	8, 9, 71, 82
The Boston Strangler (1968)	9, 11, 16
The Bostonians (1984)	51, 52
The Box (2009)	69, 91, 104
The Brink's Job (1978)	9, 31, 38
Brown of Harvard (1926)	106
Celtic Pride (1996)	7, 51, 64
Charly (1968)	6, 11, 18, 68
Cheers (1982-1993)	6
A Civil Action (1998)	7, 89
Coma (1978)	7, 18, 68
The Company Men (2010)	109, 116
The Core (2003)	69
The Departed (2006)	7, 8, 9, 28, 29, 91, 94
Edge of Darkness (2010)	6
The Equalizer (2014)	5
Everybody Wants to be Italian (2007)	48
Family Guy (1999-present)	122
Fear Strikes Out (1957)	88
Feelin' Good (1966)	49
Fever Pitch (2005)	7, 48, 88, 89, 91, 92
Field of Dreams (1989)	51, 54, 86
The Firm (1993)	51, 58
Four Days in October (2010)	89
The Friends of Eddie Coyle (1973)	5, 6, 9, 31, 32
Fuzz (1972)	11, 26
Ghosts of Girlfriends Past (2009)	48
Glory (1989)	51, 56
The Godfather (1972)	38
The Godfather: Part II (1974)	38
The Godfather: Part III (1990)	38
Gone Baby Gone (2007)	3, 5, 9, 29, 91, 96
Good Will Hunting (1997)	5, 6, 7, 28, 29, 49, 71, 76, 107
The Great Debaters (2007)	7, 91, 98, 107
Grown Ups (2010)	7
The Handmaid's Tale (1990)	69
Harvard Beats Yale 29-29 (2008)	106
Harvard Man (2001)	9, 106
The Heat (2013)	4, 5, 9
The Housesitter (1992)	49
How High (2001)	106

The Invention of Lying (2009)	48
Joe Versus the Volcano (1990)	48
Johnny Tremain (1957)	9
The Judge (2014)	5
Knight and Day (2010)	6
The Last Detail (1973)	31, 34
Left on Pearl: Women Take Over 888 Memorial Drive, Cambridge	107
Legally Blonde (2001)	7, 48, 107
Lemony Snicket's A Series of Unfortunate Events (2004)	9
Little Big League (1994)	88
Live by Night (2015)	29
Love Actually (2003)	48
Love Story (1970)	7, 11, 22, 48, 106, 107
The Matchmaker (1997)	71, 72
Moneyball (2011)	88
Monument Ave. (1998)	6, 7, 71, 78
My Best Friend's Girl (2008)	48, 91, 102
Mystery Street/Murder at Harvard (1950)	7, 8, 106
Mystic River (2001)	6, 9, 71, 86
Never Met Picasso (1996)	49
Next Stop Wonderland (1998)	6, 49, 71, 80
Now Voyager (1942)	49
Octopussy (1983)	122
Once Around (1981)	31, 44, 49
The Opposite Sex and How to Live with Them (1992)	49
The Out of Towners (1970)	11, 24
The Paper Chase (1973)	7, 31, 36, 106
The Pink Panther 2 (2009)	7
Portrait of Jennie (1968)	11, 14
Pretty Woman (1990)	48
The Proposal (2009)	7
The Proposition (1998)	49
Prozac Nation (2001)	106
Shutter Island (2010)	6, 9, 109, 110
Sleepless in Seattle (1993)	48
A Small Circle of Friends (1980)	106
The Social Network (2010)	7, 107, 109, 112
The Spanish Prisoner (1998)	71, 74
Starting Over (1970)	49
Starving Artists (1997)	49
The Sting (1973)	38
Surrogates (2009)	6, 68, 69
Ted (2012)	6, 88, 89, 109, 122
The Tenth Inning (2010)	89
This Just In...(1997)	49
The Thomas Crown Affair (1968)	9, 11, 20, 49
The Town (2010)	5, 6, 7, 9, 28, 29, 88, 109, 114
The Verdict (1982)	9, 31, 46
War of the Worlds (2005)	69
Weeds (2005-2012)	107
What's Your Number? (2011)	48, 109, 118
Whose Life is it Anyway? (1981)	7, 31, 42
The Witches of Eastwick (1987)	7
With Honors (1994)	7, 51, 62, 106, 107
The Wizard of Oz (1939)	84
X-Men 2 (2003)	69
Zookeeper (2011)	6, 109, 120